The basset-table. A comedy. As it is acted at the Theatre-Royal in Drury-Lane, by Her Majesty's servants. By the author of The gamester.

Susanna Centlivre

PRINT EDITIONS

Eighteenth Century
Collections Online
Print Editions

Gale ECCO Print Editions

Relive history with *Eighteenth Century Collections Online*, now available in print for the independent historian and collector. This series includes the most significant English-language and foreign-language works printed in Great Britain during the eighteenth century, and is organized in seven different subject areas including literature and language; medicine, science, and technology; and religion and philosophy. The collection also includes thousands of important works from the Americas.

The eighteenth century has been called "The Age of Enlightenment." It was a period of rapid advance in print culture and publishing, in world exploration, and in the rapid growth of science and technology – all of which had a profound impact on the political and cultural landscape. At the end of the century the American Revolution, French Revolution and Industrial Revolution, perhaps three of the most significant events in modern history, set in motion developments that eventually dominated world political, economic, and social life.

In a groundbreaking effort, Gale initiated a revolution of its own: digitization of epic proportions to preserve these invaluable works in the largest online archive of its kind. Contributions from major world libraries constitute over 175,000 original printed works. Scanned images of the actual pages, rather than transcriptions, recreate the works *as they first appeared.*

Now for the first time, these high-quality digital scans of original works are available via print-on-demand, making them readily accessible to libraries, students, independent scholars, and readers of all ages.

For our initial release we have created seven robust collections to form one the world's most comprehensive catalogs of 18ᵗʰ century works.

Initial Gale ECCO Print Editions collections include:

History and Geography
Rich in titles on English life and social history, this collection spans the world as it was known to eighteenth-century historians and explorers. Titles include a wealth of travel accounts and diaries, histories of nations from throughout the world, and maps and charts of a world that was still being discovered. Students of the War of American Independence will find fascinating accounts from the British side of conflict.

Social Science

Delve into what it was like to live during the eighteenth century by reading the first-hand accounts of everyday people, including city dwellers and farmers, businessmen and bankers, artisans and merchants, artists and their patrons, politicians and their constituents. Original texts make the American, French, and Industrial revolutions vividly contemporary.

Medicine, Science and Technology

Medical theory and practice of the 1700s developed rapidly, as is evidenced by the extensive collection, which includes descriptions of diseases, their conditions, and treatments. Books on science and technology, agriculture, military technology, natural philosophy, even cookbooks, are all contained here.

Literature and Language

Western literary study flows out of eighteenth-century works by Alexander Pope, Daniel Defoe, Henry Fielding, Frances Burney, Denis Diderot, Johann Gottfried Herder, Johann Wolfgang von Goethe, and others. Experience the birth of the modern novel, or compare the development of language using dictionaries and grammar discourses.

Religion and Philosophy

The Age of Enlightenment profoundly enriched religious and philosophical understanding and continues to influence present-day thinking. Works collected here include masterpieces by David Hume, Immanuel Kant, and Jean-Jacques Rousseau, as well as religious sermons and moral debates on the issues of the day, such as the slave trade. The Age of Reason saw conflict between Protestantism and Catholicism transformed into one between faith and logic -- a debate that continues in the twenty-first century.

Law and Reference

This collection reveals the history of English common law and Empire law in a vastly changing world of British expansion. Dominating the legal field is the *Commentaries of the Law of England* by Sir William Blackstone, which first appeared in 1765. Reference works such as almanacs and catalogues continue to educate us by revealing the day-to-day workings of society.

Fine Arts

The eighteenth-century fascination with Greek and Roman antiquity followed the systematic excavation of the ruins at Pompeii and Herculaneum in southern Italy; and after 1750 a neoclassical style dominated all artistic fields. The titles here trace developments in mostly English-language works on painting, sculpture, architecture, music, theater, and other disciplines. Instructional works on musical instruments, catalogs of art objects, comic operas, and more are also included.

GUIDE TO FOLD-OUTS MAPS and OVERSIZED IMAGES

The book you are reading was digitized from microfilm captured over the past thirty to forty years. Years after the creation of the original microfilm, the book was converted to digital files and made available in an online database.

In an online database, page images do not need to conform to the size restrictions found in a printed book. When converting these images back into a printed bound book, the page sizes are standardized in ways that maintain the detail of the original. For large images, such as fold-out maps, the original page image is split into two or more pages

Guidelines used to determine how to split the page image follows:

• Some images are split vertically; large images require vertical and horizontal splits.
• For horizontal splits, the content is split left to right.
• For vertical splits, the content is split from top to bottom.
• For both vertical and horizontal splits, the image is processed from top left to bottom right.

A

COMEDY,

CALL'D, THE

Baſſet - Table.

12.

THE

BASSET-Table.

A

COMEDY.

As it is Acted at the *Theatre-Royal* in *Drury-Lane*, by Her Majesty's Servants.

By the Author of the Gamester.

LONDON:

Printed for *William Turner* at the *Angel* at *Lincolns-Inn-Back-Gate*; and Sold by *J. Nutt* near *Stationers-Hall*, 1706. Price 1 s. 6 d.

To the Right Honourable

ARTHUR

Lord *ALTHAM,*

BARON of *ALTHAM,*

In the Kingdom of IRELAND.

My LORD,

POetry, in its firſt Inſtitution, was prin-
cipally deſign'd to Correct, and
rectify Manners. Thence it was
that the *Roman* and *Athenian Stages* were
accounted Schools of Divinity and Mora-
lity; where the Tragick Writers of thoſe
Days inſpired their Audiences with *Noble* and
Heroick Sentiments, and the *Comick* laugh'd
and diverted them out of their *Vices*; and
by rediculing *Folly,* *Intemperence,* and *De-*

A *bauchery,*

bauchery, gave them an Indignation for those Irregularities, and made them pursue the opposite *Virtues.*

This caus'd the *Dramatic Poets,* in ancient Times, not only to be reverenc'd by the lower sort of People, but highly Esteem'd and Courted by Persons of the first Rank; and tho' the Writers of latter Ages, have, in a greater Measure, not to say in a scandelous Manner, deviated from the Foot-steps, and Examples of their Predecessors; yet have they found Protection and Favour with those, who have been so Generous as to ascribe the Faults of the *Poets* to the Degeneracy of the *Age* wherein they liv'd.

This consideration, *my Lord,* has imbolden'd me to this Address, for tho' on the one Hand I am sensible, that the following Piece does little Merit your *Lordship's* Patronage; yet your innate Goodness and Generosity give me hopes, that your Lordship will Pardon this Intrusion, in which

which I have the Examples of all thofe that *wrote* before me to bear me out. I heartily wifh this Play were more worthy of your *Lordfhip's* Acceptance: Yet fo much, I hope, will be forgiven to the fondnefs cf a Mother for her Production; if, I fay, in its Favour, that through the whole Piece, I have had a tender regard' to good Manners, and by the main Drift of it, endeavour'd to Redicule and Correct one of the moft reigning Vices of the Age. I might fay, as many of my *Brethren* have done upon flighter Grounds, that this Play has had the good Fortune to Pleafe and Divert the Niceft, and Politeft Part of the Town; but I fhould fet little Strefs on their Applaufe, had I not fome reafon to depend upon your *Lordfhip's* Approbation, whofe Judgement, Penetration and Difcernment, are alone fufficient to do full Juftice to a performance of this Kind.

A 2 And

The DEDICATION.

And now, my *Lord*, if I follow'd the beaten Road of Dedicators, it would naturally Engage me in a *Panegirick*, upon your Lordſhip's Perſonal Virtues, and thoſe of your *Noble* and *Pious Family*; but I ſhall purpoſely decline a Talk to which I freely own my Ability is Unequal, and which, tho' manag'd by a *Maſterly Pen*, would make your Modeſty ſuffer. Therefore I ſhall conclude, with begging your *Lordſhip*'s leave to Subſcribe my ſelf, with all imaginable Reſpect and Sincerity.

My LORD,

Your Lordſhip's moſt Obedient,

and moſt Devoted

Humble Servant,

PRO-

PROLOGUE

Spoke by Mr. Penkethman.

IN all the Faces that to Plays Refort,
 Whether of Country, City, Mob or Court ;
 I've always found that none fuch hopes Infpire,
As you— dear Brethren of the Upper Tire.
Poets in Prologues, may both Preach and Rail,
Yet all their Wifdom, nothing will avail,
Who writes not up to you, 'tis ten to one will fail.
Your thundring plaudit 'tis that deals out Fame,
You make Plays run, tho' of themfelves but Lame :
How often have we known your Noife Commanding,
Impofe on your Inferior Mafters Underftanding ;
Therefore, Dear Brethren, (fince I am one of you)
Whether adorn'd in Grey, Green, Brown or Blue,
This day ftand all by me, as I will fall by you,
And now to let————
The poor Pit fee how Pinky's Voice Commands,
Silence— Now rattle all your Sticks, and clap your grimy Hands.
I greet your Love--- and let the vaineft Author fhow,
Half this Command on clearer Hands below,
Nay, more to prove your Intereft, let this Play live by you.
So may you fhare good Claret with your Mafters,
Still free in your Amours from their Difafters ;
Free from poor Houfe-keeping, where Peck is under Locks.
Free from Cold Kitchings, and no Chriftmas Box :
so may no long Debates i'th' Houfe of Commons,
Make you in the Lobby Starve, when hungar Summons :
But may your plentious Vails come flowing in,
Give you a lucky hit, and make you Gentlemen ;
And thus preferr'd, ne'er fear the World's Reproaches,
But fhake your Elbows with my Lord, and keep your Coaches:

EPILOGUE

EPILOGUE.

Spoke by Mr. Esthcourt.

THis goodly Fabrick to a gazing Tarr,
 Seems Fore and Aft, a Three Deckt-man of War:
 Abaft, the Hold's the Pit, from thence look up,
Aloft! that Swabber's Nest, that's the Main-Top.
Side-boxes mann'd with Beau, and modish Rake,
Are like the Fore-castle, and Quarter-Deck.
Those dark disguised, advent'rous, black-nos'd few,
May pass for Gunners, or a Fire-ship's Crew.
Some come like Privateers a Prize to seize,
And catch the French within the Narrow Seas.
The Orange-Ladies, Virgins of Renown,
Are Powder-Monkies running up and down.
We've here our Calms, our Storms, and prosp'rous Gales,
And shift our Scenes as Seamen shift their Sails.
The Ship's well mann'd, and not ill Woman'd neither,
So Ballast'd and Stow'd, my Lads, she'll bear the Weather.
But greater Dangers ventring Players alarm,
This Night's Engagement's worse than any Storm.
The Poet's Captain, but half dead with fright,
She leaves her Officers to maintain the Fight;
Yon'd middle Teer with Eighteen Pounders mauls us,
That Upper-Deck with Great and Small-Shot gauls us.
But from this Lower-Teer most Harm befals,
There's no opposing their prevailing Balls.
As either Foe or Friend their Chain-shot flies,
We sink or swim, we Conquer, Fall or Rise.
To fit and rig our Ships much Pains we take;
Grant we may now a Saving-Voyage make.
Here we're Embark'd, and as you Smile or Frown,
You are our Stars, by You we Live or Drown.

Dra-

Dramatis Personæ.

Men.

Mr. Mills,— Lord Worthy ————— *In Love with Lady Reveller, a hater of Gaming.*

Mr. Wilks,— Sir James Courtly— *An airy Gentleman, given to Gaming.*

Mr. Bigerstaff,— Lovely an Ensign— *In Love with Valeria.*

Mr. Bullock.— Sir Rich. Plainman— *Formerly a Citizen, but now lives in Covent-Garden, a great lover of a Soldier, and an Inverate Enemy to the French.*

Mr. Esthcourt,— Captain Hearty— *A Sea Officer, design'd by Sir Richard to Marry Valeria.*

Mr. Johnson,— Sago ————— *A Drugster in the City, very fond of his Wife.*

Mr. Penkethman— Buckle.———— *Footman to Lord Worthy*

Women.

Mrs. Oldfield,— Lady Reveller— *A Coquetish Widow, that keeps a Basset-Table.*

Mrs. Rogers,— Lady Lucy———— *Her Cousin, a Religious sober Lady.*

Mrs. Montford,— Valeria—— *A Philosophical Girl, Daughter to Sir Richard, in Love with Lovely.*

Mrs. Cross,— Mrs. Sago———— *The Drugster's Wife, a Gaming profuse Woman, great with my Lady Reveller, in Love with Sir James.*

Mrs. Lucas,— Alpiew.———— *Woman to Lady Reveller.*

Ladies, Gentlemen, for the Basset-Table.

Chair-man, Foot-men, &c.

Scene. *Lady Revellers Lodgings in* Covent-Garden; *the Time,* Four of the Clock in the Morning.

THE

THE
Baffet Table.

ACT I.

A large Hall, a Porter with a Staff, feveral Chairs Waiting, and Footmen a-fleep, with Torches and Flambeauxs ftanding about the Room.

Footman CErtainly they'l Play all Night, this is a curfed Life.

 Port. How long have you liv'd with your Lady?

 Foot A Month, too long by thirty Days, if this be her way of living; I fhall be dead before the Year's out; fhe Games all Night, and Sleeps all Day.

 Port. As long as you fleep, what's Matter?

 Foot But I do not, for while fhe fleeps, I'm Employ'd in Howdee's, from one end of the Town to the other.

Port. But you reſt while ſhe's Gaming; What would you do, if you led my Life? This is my Lady's conſtant Practice

Foot. Your Lady keeps a *Baſſet Table,* much good may do you with your Service——— Haik, they are broke up. [*within.*] ha, hy, my Lady *Gamewel*'s Chair ready there ——— Mr. *Sonic*'s Servant (*The Footmen wake ¡¡ a hurry.*

1ſt. Foot. Where the Devil is my Flambeaux?

2d. Foot. So-hey——— *Robin,* get the Chair ready, my Lady's coming; ſtay, ſtay, let me light my Flambeaux.

3d. Foot. [*waking*] Hey, hoa, what han't they done Play yet?

Port. They are now coming down, but your Lady is gone half an hour ago.

3d. Foot. The Devil ſhe is, why did not you call me?

Port. I did not ſee you.

3d. Foot. Was you Blind?——— She has loſt her Money, that's certain——— She never flinches upo naW inning-Hand——— her Plate and Jewels Walks to Morrow to repleniſh her Pocket——— a Pox of Gaming, I ſay. [*Exit.*

[*Within.*] Mr. *Looſeall*'s Man———

4th Foot. Here——— So-ho, who has ſtole my Flambeaux?

[*Within.*] My Lady *Umbray*'s Coach there.———

5th Foot. Hey! *Will,* pull up there (*Exeunt Omnes.*)

Enter Lady Reveller *and* Alpiew, *her Woman.*

Lady. My Lady *Raffle* is horridly out of humour at her ill Fortune, ſhe loſt 300 *l.*

Alp. She has generally ill luck, yet her Inclination for Play is as ſtrong as ever.——— Did your Ladyſhip win, or loſe, Madam?

Lady. I won about 50 *l.* — prethee what ſhall we do, *Alpiew*? 'Tis a fine Morning, 'tis pity to go to Bed.

Alp.

Alp. What does your Ladiſhip think of a Walk in the Park?——The Park is pleaſant in a Morning, the Air is ſo very ſweet.

Lady. I don't think ſo; the ſweetneſs of the Park is at Eleven, when the Beau *Monde* makes their Tower there, 'tis an unpoliſh'd Curioſity to walk when only Birds can ſee one.

Alp. Bleſs me, Madam! Your Uncle—— now for a Sermon of two Hours.

Enter Sir Richard Plainman, *in a Night-Gown as from Bed.*

Sir Rich. So Niece! I find you're reſolv'd to keep on your courſe of Life; I muſt be wak'd at Four with Coach, Coach, Chair, Chair; give over for ſhame, and Marry, Marry, Niece.

Lady. Now would I forfeit the Heart of my next Admirer, to know the cauſe of this Reproach. Pray, Uncle, explain'd your ſelf; for I proteſt I can't gueſs what Crime I have unhappily committed to merit this advice.

Sir Rich. How can you look me in the Face, and ask me that Queſtion? Can you that keep a Baſſet-Table, a publick Gaming-Houſe, be inſenſible of the ſhame on't? I have often told you how much the vaſt concurſe of People, which Day and Night make my Houſe their Rendevouze, incommode my Health; your Apartment is a Parade for Men of all Ranks, from the Duke to the Fidler, and your Vanity thinks they all pay Devoir to your Beauty—but you miſtake, every one has his ſeveral end in Meeting here, from the Lord to the Sharper, and each their ſeperate Intereſt to Admire——ſome Fools there may be, for there's ſeldom a crowd without.

Lady. Malice— ſome Fools? I can't bear it.

Alp. Nay, 'tis very affronting, truly Madam.

Lady. Ay, is it not *Alpiew* ?——Yet, now I think on't, 'tis the defect of Age to rail at the Pleaſure's of Youth, therefore I ſhall not diſorder my Face with a frown about it. Ha, ha, I hope, Uncle, you'l take peculiar care of my Couſin *Valeria*, in diſpoſing of her according to the Breeding you have given her.

Sir Rich. The Breeding I have given her! I would not have her have your Breeding, Miſtreſs, for all the Wealth of *England*'s Bank, no, I bread my Gal in the Country, a ſtranger to the Vices of this Town, and am reſolv'd to Marry her to a Man of Honour, Probity and Courage.

Lady What the Sea Captain, Uncle - Faugh, I hate the ſmell of Pitch and Tarr ; one that can-Entertain one with nothing but Fire and Smoak, Larboard and Starboard, and t'other Bowl of Punch, ha, ha, ha.

Alp. And for every fault that ſhe commits he'll condemn her to the Bilboes, ha, ha.

Lady. I fancy my Couſin's Philoſophy, and the Captain's Couragious Bluſter, will make Angelick Harmony.

Sir Rich. Yes, Madam, ſweeter Harmony than your *Sept & Levn* Fops, Rakes and Gameſters ; give me the Man that ſerves my Country, that preſerves both my Eſtate and Life——Oh, the glorious Name of Soldier ; if I were Young, I'd go my ſelf in Perſon, but as it is——

Alp. You'll ſend your Daughter——

Sir Rich. Yes, Minx, and a good Dowry with her, as a reward for Virtue like the Captains.

Alp. But ſuppoſe, Sir, Mrs. *Valeria* ſhould not like him ?

Sir Rich. I'll ſuppoſe no ſuch thing, Miſtreſs, ſhe ſhall like him.

Lady. Why, there 'tis now, indeed, Uncle, your're too poſitive.

Sir Rich. And you too Impertinent : Therefore I reſolve to quit your Houſe ; you ſhan't keep your Revels under the Roof where I am.

A:p.

Alp. I'd have you to know, Sir, my Lady keeps no Revels beneath her Quality.

Sir Rich. Hold your Tongue, Mrs. *Pert*, or I ſhall diſplay your Quality in its proper Colours.

Alp. I don't care, ſay your worſt of me, and ſpare not; but for my Lady——my Lady's a Widdow, and Widdows are accountable to none for their Actions——Well, I ſhall have a Husband one of thoſe days, and be a Widow too, I hope.

Sir Rich. Not unlikely, for the Man will hang himſelf the next day, I warrant him.

Alp. And if any, Uncle, pretends to controul my Actions——

Sir Rich. He'd looſe his labour, I'm certain——

Alp. I'd treat him——

Sir Rich. Don't provoke me, Houſwife, don't.

Lady. Be gone, and wait in the next Room.

(Ex. Alpieu.

Sir Rich. The Inſolence of a Servant, is a great Honour to the Lady, no doubt; but I ſhall find a way to humble you both

Lady Lookee, Unkle, do what you can, I'm reſolv'd to follow my own Inclinations.

Sir Rich. Which infallibly carries you to Noiſe, Nonſence, Foppery and Ruin; but no matter, you ſhall out of my Doors, I'll promiſe you, my Houſe ſhall no longer bear the Scandalous Name of a *Baſſet Table*: Husbands ſhall no more have cauſe to date their Ruin from my Door, nor cry there, there my Wife Gam'd my Eſtate away——Nor Children Curſe my Poſterity, for their Parents knowing my Houſe.

Lady. No more threatning, good Unkle, act as you pleaſe, but don't ſcold, or I ſhall be oblig'd to call *Alpiew* again.

Sir Rich. Very well, very well, ſee what will come on't; the World will cenſure thoſe that Game, and, in my Conſcience, I believe not without Cauſe.

For ſhe whoſe Shame, no good Advice can wake,
When Money's wanting, will her Virtue Stake. (Exit.)

Lady. Advice! Ha, ha, ridiculous Advice. (*Enter Lady* Lucy) No ſooner rid of one miſchief, but another follows——I foreſee this is to be a day of Mortification, Alpiew.

Enter Alpiew.

Alp. Madam.
Lady. My Uncle's gone, you may come in, ha, ha, ha.
L. Lucy. Fye, Couſin, does it become you to Laugh at thoſe that give you Council for your good?
Lady. For my good! Oh, mon cour? Now cannot I Divine what 'tis, that I do more than the reſt of the World, to deſerve this blame.
Alp. Nor I, for the Soul of me.
L. Lucy. Shou'd all the reſt of the World follow your Ladyſhip's Example, the order of Nature would be inverted, and every good, deſign'd by Heaven, become a Curſe, Health and Plenty no longer would be known among us. ——You croſs the purpoſe of the Day and Night, you Wake when you ſhould Sleep, and make all who have any dependence on you, Wake while you Repoſe.
Lady. Bleſs me, may not any Perſon Sleep when they pleaſe?
L. Lucy. No, there are certain Hours, that good Manners, Modeſty and Health require your Care; for Examiſorderly Hours are neither Healthful nor Modeſt——not Civil to make Company wait Dinner for your

Lady.

Lady. Why, does any body Dine before four a Clock in *London*? For my part I think it an Ill-bred Cuſtom, to make my Appetite Pendulum to the Twelfth hour.

Alp. Beſides, 'tis out of Faſhion to Dine by Day light, and ſo I told Sir *Richard* yeſterday, Madam.

L. Lucy. No doubt, but you did, Mrs. *Alpiew*; and then you entertain ſuch a Train of People, Couſin, that my Lady *Reveller* is as noted as a publick Ordinary, where every Fool with Money finds a Welcome.

Lady. Would you have me ſhut my doors againſt my Friends ———— Now ſhe is jealous of Sir *James Courtly*. (*aſide.*) Beſides, is it poſſible to paſs the Evenings without Diverſions.

Alp. No certainly ————

L. Lucy. I think the Play-houſe, the much more innocent and commendable Diverſion.

Lady. To be ſeen there every Night, in my Opinion, is more deſtructive to the Reputation.

L. Lucy. Well, I had rather be noted every Night in the front Box, then, by my abſence, once be ſuſpected of Gaming; one ruins my Eſtate and Character, the other diverts my Temper, and improves my Mind. Then you have ſuch a number of Lovers.

Lady. Oh *Cupid*, is it a Crime to have a number of Lovers? If it be, 'tis the pleaſanteſt Crime in the World. A Crime that falls not every day, to every Womans Lot.

L. Lucy. I dare be poſitive every Woman does not wiſh it.

Lady. Becauſe wiſhes have no Effect, Couſin, ha, ha.

L. Lucy Methinks my Lord *Worthy's* Aſſiduity might have baniſh'd the admiring Croud by this time.

Lady. Baniſh'd 'em? Oh, Mon cour! what pleaſure is there in one Lover; 'tis like being ſeen always in one Suit of Cloaths; a Woman, with one Admirer, will ne'er be a Reigning Toaſt.

L. Lucy.

L. Lucy. I am ſure thoſe that Encourage more, will never have the Character of a Reigning Virtue.

Lady. I ſlight the malicious Cenſure of the Town, yet defy it to aſperſe my Verture ; Nature has given me a Face, a Shape, a Mein, an Air for Dreſs, and Wit and Humour to ſubdue. And ſhall I loſe my Conqueſt for a Name.

Alp. Nay, and among the unfaſhionable ſort of People too, Madam ; for Perſons of Breeding and Quality will allow, that Gallantry and Virtue are not inſeperable.

L. Lucy. But Coquetry and Reputation are, and there is no diffierence in the Eye of the World, between having really committed the Fault, and lying under the Scandal ; for, my own part, I would take as much Care to preſerve my Fame, as you would your Virtue.

Lady. A little pains will ſerve you for that, Couſin ; for I never once heard you nam'd—— A Mortification would break my Heart, ha, ha.

L. Lucy. 'Tis better never to be nam'd, than to be ill ſpoke of; but your Reflections ſhall not Diſorder my Temper. I could wiſh, indeed, to convince you of your Error, becauſe you ſhare my Blood ; but ſince I ſee the Vanity of the attempt, I ſhall deſiſt.

Lady. I humbly thank your Ladiſhip.

Alp. Oh! Madam, here's my Lord *Worthy,* Sir *James Courtly,* and Enſign *Lovely,* coming down ; will your Ladyſhip ſee them ?

Lady. Now have I a ſtrong Inclination to Engage Sir *James,* to diſcompoſe her Gravity ; for if I have any Skill in Glances, ſhe loves him—— but then my Lord *Worthy* is ſo peeviſh ſince our late Quarrel, that I'm afraid to Engage the Knight in a Duel ; beſides, my Abſence, I know, will teize him more, therefore, upon Conſideration, I'le retire. Couſin *Lucy,* Good Morrow. I'le leave you to better Company, there's a Perſon at hand may prevent your Six-a Clock Prayers. (*Exit.*)

L. Lucy

Lucy. Ha! Sir *James Courtly*———— I muſt own I think him agreeable———— but am ſorry ſhe believes I do. I'le not be ſeen ; for if what I ſcarce know my ſelf be grown ſo viſible to her, perhaps, he too may Diſcover it, and then I am loſt.

While in the Breaſt our Secrets cloſe remain,
'Tis out of Fortunes power to give us Pain. [*Exit.*

Enter Lord Worthy, *Sir* James, *Enſign* Lovel.

Sir James. Ha! was not that Lady *Lucy* ?

Enſign. It was———— ah, Sir *James,* I find your Heart is out of Order about that Lady, and my Lord *Worthy* lan-guiſhes for Lady *Reveller.*

Sir James. And thou art ſick for *Valeria,* Sir *Richard's* Daughter. A poor diſtreſſed Company of us.

Enſign, 'Tis true, that little ſhe-Philoſopher has made me do Pennance more heartily than ever my ſins did ; I deſerve her by meer Dint of Patience. I have ſtood whole hours to hear her Aſſert that Fire cannot Burn, nor Water Drown, nor Pain Afflict, and forty ridiculous Syſtems——— and all her Experiments on Frogs, Fiſh——— and Flies, ha, ha, ha, without the leaſt Contradiction.

Enſign. Contradiction, no, no, I allow'd all ſhe ſaid with undoubtedly, Madam,——— I am of your mind, Ma-dam, it muſt be ſo——— natural Cauſes, *&c.*

Sir James. Ha, ha, ha, I think it is a ſupernatural cauſe which Enables thee to go thro' this Fatigue, if it were not to raiſe thy Fortune, I ſhould think thee Mad to purſue her ; but go on and proſper, nothing in my Power ſhall be wanting to aſſiſt you——— My Lord *Worthy*——— your Lordſhip is as Melancholy as a loſing Gameſter

Lord. Faith, Gentlemen, I'm out of Humour, but I don't know at what.

Sir

Sir James Why then I can tell you, for the very same reason that made your Lordship stay here to be Spectator of the very Diversion you hate— Gaming— the same Cause makes you uneasy in all Company, my Lady *Reveller.*

Lord. Thou hast hit it, *James,* I confess I love her Person, but hate her Humours, and her way of Living; I have some reasons to believe I'm not indifferent to her, yet I despair of fixing her, her Vanity has got so much the Mistress of her Resolution; and yet her Passion for Gain surmounts her Pride, and lays her Reputation open to the World Every Fool that has ready Money, shall dare to boast himself her very humble Servant, 'ds Death, when I could cut the Rascal's Throat.

Sir James. your Lordship is even with her one Way, for you are as testy as she's vain, and as fond of an opportunity to Quarrel with her, as she of a Gaming Acquaintance; my Opinion is, my Lord, she'll ne're be won your Way.

> *To gain all Women there's a certain Rule,*
> *If Wit should fail to please, then Act the Fool;*
> *And where you find simplicity not take,*
> *Throw off Disguises— and Profess the Rake;*
> *Observe which Way their chiefest Humours run,*
> *They're by their own lov'd, can't the surest Way undone.*

Lord. Thou'rt of a happy temper, Sir *James,* I wish I could be so too; but since I can't add to your Diversion, I'll take my leave, good Morrow, Gentlemen (*Exit*)

Sir James. This it is to have more Love than Reason about one; you and I *Lovely* will go on with Discretion, and yet I fear it's in Lady *Lucy*s Power to banish it.

Ensign I find Mrs. *Sago,* the Drugsters Wife's Interest, begins to shake, Sir *James.*

Sir James. And I fear her Love for Play begins to shake her Husband's Baggs too— faith, I am weary of that Intreague, lest I should be suspected to have a hand in his Ruin. *Ensign.*

Enſign She did not loſe much to Night, I believe ; preethy, Sir *James*, what kind of a temper'd Woman is ſhe ? Has ſhe Wit ?

Sir James. That ſhe has—— A large Portion, and as much Cunning, or ſhe could never have manag'd the old Fellow ſo nicely ; ſhe has a vaſt Paſſion for my Lady *Re-telʒ*, and endeavours to mimick her in every thing—— Not a ſute of Cloaths, or a Top-knot, that is not exactly the ſame with hers—— then her Plots and Contrivances to ſupply theſe Expences, puts her continually upon the Rack , yet to give her her due, ſhe has a fertile Brain that Way; but come, ſhall we go home and ſleep two or three Hours, at Dinner I'll introduce you to Capt. *Hearty*, the Sea Officer, your Rival that is to be, he's juſt come to Town.

Enſign. A powerful Rival, I fear, for Sir *Richard* reſolves to Marry him to his Daughter; all my hopes lyes in her Arguments, and you know Philoſophers are very poſitive---and if this Captain does but happen toContradict oneWhimſical Notion, the Poles will as ſoon join, as they Couple, and rather then yield, ſhe would go to the Indies in ſearch of *Dampier*'s Ants.

Sir James. Nay, ſhe is no Woman if ſhe Obeys.

Women like Tides with Paſſions Ebb and Flow,
And like them too, their ſource no Man can know.
To watch their Motions, is the ſafeſt Guide,
Who hits their Humour, Sails with Wind and Tide.

[Exit.

The End of the Firſt ACT.

ACT II.

Enter Buckle, *meeting Mrs.* Alpiew.

Alp. Good Morrow.

　　Buckle. Good Morrow.

Alp. Good Morrow, good Morrow, is that all your business here; What means that Affected Look, as if you long'd to be examin'd what's the Matter.

Buc. The Capricio's of Love, *Madamoselle*; the Capricio's of Love.

Alp. Why——— are you in Love?

Buc. I——— in Love? No, the Divel take me if ever I shall be infected with that Madness, 'tis enough for one in a Family to Fall under the whimsical Circumstances of that Distemper. My Lord has a sufficient Portion for both; here— here— here's a Letter for your Lady, I believe the Contents are not so full of Stars and Darts, and Flames, as they us'd to be.

Alp. My Lady will not concern her self with your Lord, nor his Letters neither, I can assure you that.

Buc. So much the better, I'le tell him what you say——— Have you no more?

Alp. Tell him it is not my fault, I have done as much for his Service, as lay in my Power, till I put her in so great a Passion, 'tis impossible to Appease her.

Buckle Very good—— my Lord is upon the Square, I promiſe ye, as much inraged as her Ladiſhip to the full. Well, Mrs. *Alpiew*, to the longeſt Day of his Life he ſwears, never to forget Yeſterday's Adventure, that's given him perfect, perfect Liberty.

Alp. I believe ſo—— What was it, pray?

Buckle. I'll tell you; 'twas a matter of Conſequence, I aſſure you, I've known Lovers part for a leſs Triffle by half.

Alp. No Diſgreſſions, but to the point, what was it?

Buckle. This—— my Lord, was at the Fair with your Lady.

Alp. What of that?

Buckle. In a Raffling-ſhop ſhe ſaw a young Gentleman, which ſhe ſaid was very handſom—— At the ſame time, my Lord, prais'd a young Lady; ſhe redoubles her Commendations of the Beau—— He enlarges on the Beauty of the Bell; their Diſcourſe grew warm on the ſubject; they Pauſe; ſhe begins again with the Perfections of the Gentleman; he ends with the ſame of the Lady; Thus they perſu'd their Arguments, ſtill finding ſuch mighty Charms in their new Favourites, till they found one another ſo Ugly—— ſo Ugly—— that they parted with full Reſolutions never to meet again.

Alp. Ha, ha, ha, pleaſant; well, if you have no more to tell me, adieu.

Buckle. Stay a Moment, I ſee my Lord coming, I thought he'd follow me. Oh, Lovers Reſolutions——

Enter Lord Worthy.

Lord. So, have you ſeen my Lady *Reveller?* (*To Buckle.*

Alp. My Lord——

Lord. Ha! Mrs. *Alpiew.*

Buckle. There's your Lordſhip's Letter.

(*Gives him his own Letter.*
Lord.

Lord. An Anſwer! She has done me very much Honour.

Alp. My Lord, I am commanded——

Lord. Hold a little, dear Mis. *Alpiew.* (all the while he is opening the letter, thinking a favour Lady)

Alp. My Lord, ſhe would not——.

Lord. Be quiet, I ſay—— —.

Alp. I am very ſorry——

Lord. For a moment——— Ha, why, this, 'um, over letter.

Buckle. Yes, my Lord.

Lord. Yes, my Lord—— what, ſhe'd not receive it then

Buckle. No, my Lord.

Lord. How durſt you ſtay ſo long

Alp. I beg your Lordſhip not to harbour an ill Opinion of me, I oppoſed her anger with my utmoſt Skill, prais'd all your Actions, all your Parts, but all in Vain.

Lord. Enough, Enough, Madam, ſhe has taken the beſt method in the World—— Well, then we are ne'er to meet again?

Alp. I know not that, my Lord——

Lord. I am over-joy'd at it, by my Life I am, ſhe has only prevented me ; I came a purpoſe to break with her——

Buckle. (*aſide*) Yes, ſo 'twas a ſign by the pleaſure you diſcover'd, in thinking ſhe had writ to you.

Lord. I ſuppoſe, ſhe has entertain'd you with the Cauſe of this ?

Alp. No, my Lord, never mention'd a Syllable, only ſaid, ſhe had for ever done with you ; and charg'd me, as I valued her favour, to receive no Meſſage nor Letter, from you.

Lord. May I become the very'ſt Wretch alive, and all the Ills immaginable fall upon my Head, if I ſpeak to her more ; nay, ever think of her but with Scorn—— Where s ſhe now ? (*Walks about*)

 Alp.

Alp. In her Dreſſing-room.

Lord. There let her be, I am weary of her fantaſtick Humours, affected Airs, and unaccountable Paſſions.

Buckle. For half an Hour. (*Aſide*)

Lord. Do you know what ſhe's a doing?

Alp. I believe, my Lord, trying on a Mantua; I left her with Mrs. *Pleatwell,* and that us'd to hold her a great while, for the Woman is ſaucily Familiar with all the Quality, and tells her all the Scandal.

Lord. And conveys Letters upon occaſion; 'tis tack'd to their Profeſſion——But, my Lady *Reveller* may do what ſhe pleaſes, I am no more her Slave, upon my Word; I have broke my Chain——She has not been out then ſince ſhe Roſe?

Alp. No, my Lord.

Lord. Nay, if ſhe has, or has not, 'tis the ſame thing to me; ſhe may go the end of the World, if ſhe will; I ſhan't take any pains to follow her—— Whoſe Footman was that I met?

Alp. I know not, my Lord, we have ſo many come with How-dee's, I ne'er mind them.

Lord. You are uneaſy, Child, come, I'll not detain you, I have no curioſity, I proteſt I'm ſatisfied if ſhe's ſo, I aſſure ye, let her deſpiſe me, let her hate me, 'tis all one, adieu. (*Going.*

Alp. My Lord, your Servant.

Lord. Mrs *Alpiew,* let me beg one favour of you, (*turns back.*) not to ſay I was here.

Alp. I'll do juſt as you pleaſe, my Lord.

Lord. Do that then, and you'll oblige me,

Alp. I will (*Is going, and comes back often.*)

Lord. Don't forget.

Alp. Your Lordſhip may depend upon me.

Lord. Hold, now I think on't——Pray tell her you did ſee me, do ye hear?

Alp. With all my Heart.

Lord

Lord. Tell her how indifferent she is to me in every respect.

Alp. I shan't fail.

Lord. Tell her every thing, just as I exprest it to you.

Alp. I will.

Lord. Adieu (*going.*)

Alp. Your Servant.

Lord. Now, I think on't, Mrs *Alpiew*, I have a great mind she shou'd know my Sentiments from my own Mouth

Alp. Nay, my Lord, I can't promise you that.

Lord. Why '

Alp. Because she has expresly forbid your admittance

Lord. I'd speak but one Word with her.

Alp. Impossible

Lord. Pugh, prethee do, let me see her, (*intreating Mrs Alpiew.*)

Buckle. So now, all this mighty rage ends in a begging Submission.

Lord. Only tell her I'm here.

Alp. Why should you desire me to meet her Anger, my Lord ?

Lord. Come, you shall oblige me once.
 (*Puts a Ring upon her Finger.*)

Alp. Oh, dear, my Lord, you have such a command over your Servant, I can refuse nothing. *Exit.*)

Lord. Have you been at the Goldsmiths about the Bills, for I am fix'd on Travelling.

Buck. Your Lordship's so disturb'd, you have forgot you Countermanded me, and send me hither.

Lord. True

Enter Mrs. Alpiew.

Alp. Just as I told your Lordship, she fell in a most violent Passion, at the bare mention of your Name; tell him,
 said

ſaid ſhe, in a heroick Strain, I'll never ſee him more, and command him to quit that Room, 'cauſe I'm coming to't.

Lord. Tyrant, curſe on my Follies, ſhe knows her Power; well, I hope, I may walk in the Gallery ; I would ſpeak with her Uncle.

Alp. To be ſure, my Lord.　　　(*Exit.* Lord Worthy.)

Buck. Learn, Miſtreſs, learn, you may come to make me glad in time, ha, ha, ha.

Alp. Go Fool, follow your Lord.　　　(*Exit.* Buckle.)

Enter Lady Reveller.

Lady. Well, I'll ſwear, *Alpiew*, you have given me the Vapours for all Day

Alp. Ah ' Madam, if you had ſeen him, you muſt have had Compaſſion . I would not have ſuch a Heart of Adamant for the World ; poor Lord, ſure you have the ſtrangeſt Power over him

Lady. Silly—— one often Fancies one has Power, when one has none at all; I'll tell the *Alpiew*, he vex'd me ſtrangely before this grand Quarrel; I was at *Picquet* with my Lady *Love-Witt* four Nights ago, and bid him read me a new Copy of Verſes, becauſe, you know, he never Plays, and I did not well know what to do with him; he had ſcarce begun, when I being eager at a Pique, he roſe up, and ſaid, he believ'd I lov'd the Muſick of my own Voice, crying Nine and Twenty, Threeſcore, better than the ſweeteſt Poetry in the Univerſe, and abruptly left us.

Alp. A great Crime, indeed, not to read when People are at a Game they are oblig'd to talk to all the while.

Lady. Crime, yes, indeed was it, for my Lady loves Poetry better than Play, and perhaps before the Poem had been done had loſt her Money to me. But, I wonder, *Alpiew*, by what Art 'tis you engage me in this Diſcourſe, why

D　　　　　ſhou'd

ſhou'd I talk of a Man that's utterly my Averſion— Have you heard from Mrs. *Sago* this Morning?

Alp. Certainly, Madam, ſhe never fails; ſhe has ſent your Ladiſhip the fineſt Cargo made up of Chocolate, Tea, Montifiaſco Wine, and 50 Rarities beſide, with ſomething to remember me, good Creature, that ſhe never forgets. Well, indeed, Madam, ſhe is the beſt natur'd Woman in the World; it grieves me to think what Sums ſhe loſes at Play.

Lady. Oh fye, ſhe muſt, a Citizen's Wife is not to be endur'd amongſt Quality; had ſhe not Money, 'twere impoſſible to receive her———

Alp. Nay, indeed, I muſt ſay that of you Women of Quality, if there is but Money enough, you ſtand not upon Birth or Reputation, in either Sex; if you did, ſo many Sharpers of *Covent-Garden*, and Miſtreſſes of St. *James's*, would not be daily admitted.

Lady. Peace, Impertinence, you take ſtrange Freedoms.
[*Enter* Veleria *running.*]
Why in ſuch haſt Couſin *Valeria.* [*Stopping her*]

Val. Oh! dear Couſin, don't ſtop me, I ſhall loſe the fineſt Inſect for Deſection, a huge Fleſh Fly, which Mr. *Lovely* ſent me juſt now, and opening the Box to try the Experiment away it flew.

Lady. I am glad the poor Fly eſcap'd; will you never be weary of theſe Whimſies?

Val. Whimſies! natural Peiloſophy a Whimſy! Oh, the unlearn'd World

Lady. Ridiculous Learning?

Alp. Ridiculous, indeed, for Women; Philoſophy Sutes our Sex, as Jack Boots would do.

Val. Cuſtom would bring them as much in Faſhion as Furbeloes, and Practice would make us as Valiant as e're a Hero of them all; the Reſolution is in the Mind,——— Nothing can enſlave that.

Lady. My Stars! this Girl will be Mad, that's certain.

Val.

Mad. ſo *Nero* Baniſh'd Philoſophers from *Rome*, and the firſt Diſcoverer of the *Antipodes* was Condemn'd for a Heretick.

Lady. In my Conſcience, *Alpiew*, this pritty Creature's ſpoil'd. Well, Couſin, might I Adviſe, you ſhould beſtow your Fortune in Founding a College for the Study of Philoſophy, where none but Women ſhould be admitted, and to Immortalize your Name, they ſhould be call'd *Valerians*, ha, ha, ha.

Val. What you make a Jeſt of, Id'e Execute, were Fortune in my Power.

Alp. All Men would not be Excluded, the handſom Enſign, Madam.

Lady. In Love? Nay, there's no Philoſophy againſt Love, *Solon* for that.

Val. Piſha, no more of this Triffling Subject; Couſin, will you believe there's any thing without Gaul?

Lady. I am ſatisfy'd I have one, when I loſe at Play, or ſee a Lady Addreſt when I am by, and 'tis equal to me, whether the reſt of the Creation have or not.

Val. Well, but I'le convince you then, I have diſſected my Dove— and poſitively I think the Vulgar Notion true, for I could find none.

Lady. Oh, Barbarous; kill'd your pritty Dove! [*Starting.*

Val. Kill'd it! Why, what did you Imagine I bred it up for? Can Animals, Inſects or Reptils, be put to a Nobler uſe, than to improve our Knowledge? Couſin, I'll give you this Jewel for your *Italian* Grey-hound.

Lady. What, to Cut to Pieces? Oh, horrid! he had need be a Soldier that ventures on you, for my part, I ſhould Dream of nothing but Inciſion, Diſſection and Amputation, and always fancy the Knife at my Throat.

Enter Servant. Madam, here's Sir *Richard*, and a——

Val. A—— What, is it an Accident, a Subſtance, a Material Being, or, a Being of Reaſon?

Serv. I don't know what you call a Material Being; it is a Man.

Val. P'sha, a Man, that's nothing

Lady. She'll prove by and by out of *Diſcartes*, that we are all Machines. (*Enter Sir* Richard, *and Capt.* Firebrand.)

Alp. Oh, Madam, do you ſee who obſerves you ? My Lord walking in the Gallery, and every Minute gives a Peep.

Lady. Does he ſo ‑ I'll fit him for Eves-dropping‑‑‑‑‑‑

Sir Rich. Sir, I like the Relation you have given me of your Naval Expedition, your Diſcourſe ſpeaks you a Man fit for the Sea

Capt. You had it without a flouriſh, Sir *Richard*, my Word is this, I hate the *French*, Love a handſome Woman, and a Bowl of Punch

Val. Very Blunt.

Sir Rich. This is my Daughter, Captain, a Girl of ſober Education; ſhe underſtands nothing of Gaming, Parks and Plays.

Mrs. Alp But wanting theſe Diverſions, ſhe has ſupply'd the Vacancy with greater Follies. [*Aſide*]

Capt. A Tite little Frigate, [*Salutes her*] Faith, I think, ſhe looks like a freſhman Sea-ſick‑‑‑‑ but here's a Gallant Veſſel‑‑‑‑ with all her Streamers out, Top and Top Gallant‑‑‑‑ with your leave, Madam, (*Salutes her*) who is that Lady, Sir *Richard* ‑

Sir Rich. 'Tis a Niece of mine, Captain‑‑‑‑ tho' I am ſorry ſhe is ſo, ſhe values nothing that does not ſpend their days at their Glaſs, and their Nights at *Baſſet*, ſuch who ne'er did good to their Prince, nor Country, except their Taylor, Peruke-maker, and Perfumer

Lady Fy, fy, Sir, believe him not, I have a Paſſion, an extream Paſſion, for a Hero‑‑‑‑ eſpecially if he belongs to the Sea; methinks he has an Air ſo Fierce, ſo Piercing, his very Looks commands Reſpect from his own Sex, and all the Hearts of ours.

 Sir

Sir Rich. The Divel—— Now, rather than let another Female have a Man to her ſelf, ſhe'll make the firſt Advances. (*aſide.*)

Capt. Ay, Madam, we are preferr'd by you fine Ladies ſometimes before the ſprucer Sparks—— there's a Conveniency in't; a fair Wind, and we hale out, and leave you Liberty and Money, two things the moſt acceptable to a Wife in Nature.

Lad., Oh! ay, it is ſo pretty to have one's Husband gone Nine Months of the Twelve, and then to bring one home fine China, fine Lace, fine Muſlin, and fine Indian Birds, and a thouſand Curioſities.

Sir Rich. No, no, Nine is a little too long, ſix would do better for one of your Conſtitution, Mrs

Capt. Well, Madam, what think you of a cruiſing Voyage towards the Cape of Matrimony, your Father deſigns me for the Pilot, if you agree to it, we'll hoiſt Sail immediately.

Val. I agree to any thing dictated by good Senſe, and comprehended within the Borders of Elocution, the converſs I hold with your Sex, is only to improve and cultivate the Notions of my Mind

Sir Rich. What the Devil is ſhe going upon now [*Aſide.*

Val. I preſume you'r a Mariner, Sir——

Capt. I have the Honour to bear the Queen's Commiſſion, Madam.

Val. Pray, ſpeak properly, poſitively, Laconically and Naturally.

Lady So ſhe has given him a Broadſide already.

Capt. Laconically · Why, why, what is your Daughter · Sir Richard, ha

Sir Rich. May I be reduc'd to Wooden-Shoes, if I can tell you, the Devil ; had I liv'd near a College, the Haunts of ſome Pedaunt might have brought this Curſe upon me ; but to have got my Eſtate in the City, and to have a Daughter run Mad after Philoſophy, I'll ne'er ſuffer it in

the

the rage I am in, I'll throw all the Books and Mathemati-
cal Inſtruments out of the Window.

Lady. I dare ſay, Uncle, you have ſhook hands with
Philoſophy— for I'm ſure you have baniſh'd Patience, ha
ha, ha.

Sir Rich. And you Diſcretion———By all my hatred for
the *French*, they'll drive me Mad; Captain I'll expect you
in the next Room, and you Mrs *Laconick*, with your Phi-
loſophy at your Tail. (*Exit*)

Lady. Shan't I come too, Uncle, ha, ha.

Capt. By *Neptune*, this is a kind of a whimſical Family;
well, Madam, what was you going to ſay ſo poſitively and
properly, and ſo forth?

Val. I would have ask'd you, Sir, if ever you had the
curioſity to inſpect a Mermaid——— Or if you are convinc'd
there is a World in every Star———We, by our Telliſcopes,
find Seas, Groves and Plains, and all that; but what they
are Peopled with, there's the Query.

Capt. Let your next Contrivance be how to get thither,
and then you'll know a World in every Star———Ha, ha,
ſhe's fitter for *Moorfields* than Matrimony, pray, Madam,
are you always infected, full and change, with this Diſtem-
per?

Val. How has my reaſon err'd, to hold converſe with
an irrational Being———Dear, dear Philoſophy, what im-
menſe pleaſures dwell in thee!

Enter Servant.

Serv. Madam, *John*, has got the Fiſh you ſent him in
ſearch of.

Val. Is it alive?

Serv. Yes, Madam.

Val. Your Servant, your Servant, I wou'd not loſe the
Experiment for any thing, but the tour of the new World.
 (*Exit.*
 Capt.

Capt. Ha, ha, ha, is your Ladiſhip troubled with theſe Vagaries too; is the whole Houſe poſſeſt?

Lady. Not I, Captain, the ſpeculative faculty is not my Talent; I am for the practick, can liſſen all Day, to hear you talk of Fire, ſubſtantial Fire, Rear and Front, and Line of Battle——admire a Seaman, hate the *French*,--- love a Bowl of Punch? Oh, nothing ſo agreeable as your Converſation, nothing ſo Jaunty as a Sea Captain.

Alp. So, this engages him to Play,——If he has either Manners or Money. (*aſide.*

Capt. Ay, give me the Woman that can hold me tack in my own Dialect——She's Mad too, I ſuppoſe, but I'll humour her a little. (*aſide*) Oh, Madam, not a fair Wind, nor a rich Prize, nor Conqueſt o're my Enemies, can pleaſe like you; accept my Heart without Capitulation ——'Tis yours, a Priſoner at Diſcretion. (*Kiſſes her Hand*

Enter Lord Worthy.

Lord. Hold, Sir, you muſt there contend with me; the Victory is not ſo eaſy as you imagine.

Lady. Oh fye, my Lord, you won't fight for one you hate and deſpiſe? I may truſt you with the Captain, ha, ha, ha. (*Exit.*

Capt. This muſt be her Lover——And he is Mad another way; this is the moſt unaccountable Family I ever met with. (*aſide*) Lookye, Sir, what you mean by contending I know not; but I muſt tell you, I don't think any Woman I have ſeen ſince I came aſhoar worth Fighting for. The Philoſophical Gimcrack I don't value of a Cockle Shell——And am too well acquainted with the danger of Rocks and Quick-ſands, to ſteer into t'others Harbour.

Lord. He has diſcover'd her already; I, only I, am blind. (*aſide.*)

Capt.

Capt. But, Sir, if you have a mind to a Breathing, here tread upon my Toe, or speak but one Word in favour of the *Poet*, or against the Courage of our Fleet, and my Sword will start of its felf, to do its Master, and my Country, Justice.

Lord. How ridiculous do I make my felf— Pardon me, Sir, you are in the right. I confefs I fcarce knew what I did.

Capt. I thought fo, poor Gentleman, I pitty him; this is the effect of Love on fhoar—When do we hear of a Tarr in thefe fits, longer then the firft frefh Gale—Well, I'll into Sir *Richard*, Eat with him, Drink with him: but to Match into his Generation, I'd as foon Marry one of his Daughters Mermaids　　　　　　　　　　　　*(Exit.)*

Lord. Was ever Man fo stupid as my felf? But I will roufe from this Lethargick Dream, and feek elfewhere what is deny'd at home, abfence may reftore my Liberty.

<div style="text-align:center">

Enter Mr. Sago.

</div>

Sago. Pray, my Lord, did you fee my *Keecky*.

Lord. *Keecky,* what's that?

Sago. My Wife, you muft know, I call her *Keecky,* ha, ha.

Lord Not I, indeed ———

Sago. Nay, pray my Lord, ben't angry, I only want her, to tell her what a Prefent of fine Wine is fent her juft now; and ha, ha, ha, ha, what makes me Laugh—— Is that, no Soul can tell from whence it comes.

Lord. Your Wife knows, no doubt.

Sago. No more than my felf, my Lord— We have often Wine and Sweet-meats, nay, whole pieces of Silk, and the duce take me, if fhe could devife from whence; nay, fometimes fhe has been for fending them back again, but I cry'd, whofe a Fool then———

Lord, I'm fure thou art one in perfection, and to me infupportable.　　　　　　　　　　　　　　　*[Going]*

<div style="text-align:right">

Sago.

</div>

Sago. My Lord, I know your Lordſhip has the Privi-ledge of this Houſe, pray do me the Kindneſs if you find my Wife to ſend her out to me.　　　[*Exit* Lord.]

I ne'er ſaw ſo much of this Lord's Humour before ; he is very Surly Methinks — Adod there are ſome Lords of my Wives Acquaintance, as Civil and Familiar with me, as I am with my Journeyman—Oh ! here ſhe comes.

Enter Mrs. Sago and Alpiew.

Mrs. Sago. Oh Puddy, ſee what my Lady *Reveller* has preſented me withal.

Sago. Hey Keecky, why ſure you Riſe——as the ſaying is, for at Home there's Four Hampers of Wine ſent ye.

Mrs. Sago. From whence, Dear Puddy ?

Sago. Nay, there's the Jeſt, neither you nor I know. I offer'd the Rogue that brought it a Guinea to tell from whence it came, and he Swore he durſt not.

Mrs. Sago. No, if he had I'd never have Employ'd him again.　　　　　　　　　　　[*Aſide.*]

Sago. So I gave him Half a Crown, and let him go.

Mrs. Sago. It comes very Opportunely pray Puddy ſend a Couple of the Hampers to my Lady *Reveller* as a ſmall Acknowledgement for the Rich Preſent ſhe has made me.

Sago. With all my Heart, my Jewel, my Precious.

Mrs. Sago. Puddy, I am ſtrangely oblig'd to Mrs. *Al-piew*, do, Puddy, do, Dear Puddy.

Sago. What ?

Mrs. Sago. Will ye, then ? Do, Dear Puddy, do, lend me a Guinea to give her, do.
　　　　　　　　[*Hanging upon him in a Wheedling Tone.*]

Sago. P'ſhaw, you are always wanting Guineas, I'll ſend her Half a Pound of *Tea*, Keecky.

Mrs. Sago. Tea——ſha——ſhe Drinks Ladies *Tea* ; do, Dear Pudd, do ; can you deny Keecky now ?

Sago. Well, well, there. (*Gives it her.*)

Mrs. Sago. Mrs. *Alpiew*, will you please to lay the Silk by for me, till I send for it, and accept of That?

Alp. Your Servant Madam, I'll be careful of it.

Mrs. Sago. Thank ye, Borrow as much as you can on't, Dear *Alpiew*. [*Aside to her.*]

Alp. I warrant you, Madam. [*Exit.*]

Mrs. Sago. I must Raise a Summ for *Basset* against Night.

Mr. Sago. Preethy Keecky, what kind of Humour'd Man is Lord *Worthy* ? I did but ask him if he saw thee, and I Thought he would snapp'd my Nose off.

Mrs. Sago. Oh a meer Woman, full of Spleen and Vapours, he and I never agree.

Mr. Sago. Adod, I thought so —— I guess'd he was none of thy Admirers.—— Ha, ha, ha, why there's my Lord *Courtall*, and my Lord *Harwich*, bow down to the Ground to me wherever they meet me.

Enter Alpiew.

Alp. Madam, Madam, the *Goldsmith* has sent in the Plate.

Mrs. Sago. Very well, take it along with the Silk.
 [*Aside to her.*]

Alp. Here's the *Jeweller*, Madam, with the Diamond Ring, but he don't seem willing to leave it without Money.
 [*Exit* Alpiew.]

Mrs. Sago. Humph? I have a sudden Thought, bid him stay, and bring me the Ring—— Now for the Art of Wheedling.——

Sago. What are you Whispering about? Ha? Precious.——

Mrs. Sago. Mrs. *Alpiew* says, a Friend of her has a Diamond Ring to Sell, a great Penny-worth and I know you love a Bargain Puddy.]

Enter

Enter Alpiew, *gives her the Ring.*

Sago. P'shaw, I don't care for Rings; it may be a Bargain, and it may not; and I can't spare Money; I have Paid for a Lot this Morning; confider Trade muft go forward, Lambkin.

Alp. See how it Sparkles.

Mrs. Sago. Nay, Puddy, if it be not Worth your Money I don't defire you to Buy it; But don't it become my Finger, Puddy ? See now.——

Sago. Ah ! that Hand, that Hand it was which firft got hold of my Heart; well what's the Price of it; Ha, I am ravifh'd to fee it upon Keecky's Finger.——

Mrs. Sago. What did he fay the Price was ? [*To* Alpiew.]

Alp. Two Hundred Guineas, Madam. [*Afide to* Mrs. Sago.]

Mrs. Sago. Threefcore Pound,——Dear Pudd, the Devils in't if he won't give that. [*Afide.*]

Sago. Threefcore Pounds ? Why 'tis Worth a Hundred Child, Richly——'tis Stole——'tis Stole.——

Alp. Stole ? I'd have you to know the Owner is my Relation, and has been as great a Merchant as any in *London,* but has had the Misfortune to have his Ships fall into the Hands of the *French,* or he'd not have parted with it at fuch a Rate; it Coft him Two Hundred *Guineas.*

Mrs. Sago. I believe as much, indeed 'tis very fine.

Sago. So it is Keecky, and that Dear little Finger fhall have it to let me Bite it; a little Tiny bit.——[*Bites her Finger.*]

Mrs. Sago. Oh! Dear Pudd, you Hurt me.

Sago. Here ——I han't fo much Money about me, but ther's a Bill, Lambkin——there now, you'll Bufs poor Puddy now, won't you ?

Mrs. Sago. Bufs him—— yes that I will agen, and agen, and agen Dear Pudd. [*Flies about his Neck.*]

Sago. You'll go Home with Puddy now to Dinner, won't you ?

Mrs. Sago. Yes——a——Dear Puddy, if you deſire it——
I will——but——a——

Sago. But what?

Mrs. Sago. But I promis'd my Lady *Reveller* to Dine
with her, Deary——do, let me Pudd——I'll Dine with you
to Morrow-day.

Alp. Nay, I'm ſure my Lady won't Eat a bit if ſhe don't
ſtay.

Sago. Well, they are all ſo Fond of my Wife, by Keecky,
ſhow me the Little Finger agen—— Oh! Dear Little Fin-
ger, by by Keecky. [*Aſide.*]

Mrs. Sago. By own Pudd ——Here *Alpiew* give him his
Ring agen, I have my End, tell him 'tis to Dear.

Alp. But what will you ſay when Mr. *Sago* Miſſes it.

Mrs. Sago. I'll ſay —— that it was two big for my
Finger, and I loſt it; 'tis but a Crying-bout, and the good
Man melts into Pity——

I'th' Married State, this only Bliſs we find,

An Eaſie Husband to our Wiſhes kind.

Iv'e Gain'd my Point, Repleniſh'd Purſe once more,

Oh! caſt me Fortune on the Winning Shore.

Now let me Gain what I have Loſt before,

[*Exit.*]

A C T.

ACT. III.

The Scene draws, and diſcovers Valeria *with Books upon a Table, a Microſcope, putting a Fiſh upon it, ſeveral Animals lying by.*

Val. SHA! Thou fluttering Thing. ———— So now I've fix'd it.

Enter Alpiew.

Alp. Madam, here's Mr. *Lovely* ; I have introduc'd him as One of my Lady's Viſitors, and brought him down the Back-ſtairs.

Val. I'm oblig'd to you, he comes opportunely.

Enter Lovely.

Oh ! Mr. *Lovely*, come, come here, look through this Glaſs, and ſee how the Blood Circulates in the Tale of this Fiſh.

Lovely. Wonderful ! but it Circulates prettier in this Fair Neck.

Val. Pſhaw—— be quiet———— I'll ſhew you a Curioſity, the greateſt that ever Nature made———[*opens a Box*] in opening a Dog the other Day I found this Worm.

Lovely. Prodigious ! 'tis the Joint-Worm, which the Learned talk of ſo much.

Val. Ay, the *Lumbricus Latus*, or *Fæſcia*, as *Hippocrates* calls it, or Vulgarly in *Engliſh* the Tape-Worm.—— *Thudæus* tells us of One of theſe Worms found in a Human Body 200 Foot long, without Head or Tail.

Lovely.

Lovely. I wish they be not got into thy Brain. [*Aside.*]
Oh you Charm me with these Discoveries.

Val. Here's another Sort of Worm call'd *Lumbricus te-res Intestinalis.*

Lovely. I think the First you show'd me the greatest Curiosity.

Val. 'Tis very odd, really, that there should be every
Inch a Joint, and every Joint a Mouth.——— Oh the profound Secrets of Nature !

Lovely. 'Tis strangely Surprizing.——— But now let me
be heard, for mine's the Voice of Nature too ; methinks
you neglect your self, the most Perfect Piece of all her
Works.

Val. Why ? What Fault do you find in me ?

Lovely. You have not Love enough ; that Fire would
Consume and Banish all Studies but its own ; your Eyes
wou'd Sparkle, and spread I know not what, of Lively and
Touching, o'er the whole Face ; this Hand, when Press'd
by him you Love, would Tremble to your Heart.

Val. Why so it does,——— have I not told you Twenty Times I Love you,——— for I hate Disguise ; your
Temper being Adapted to mine, gave my Soul the First Impression ;——— you know my Father's Positive,——— but
do not believe he shall Force me to any Thing that does not
Love Philosophy.

Lovely. But that Sea Captain *Valeria.*

Val. If he was a Whale he might give you Pain, for I
should long to Dissect him ; but as he is a Man, you have
no Reason to Fear him.

Lovely. Consent then to Fly with me.

Val. What, and leave my Microscope, and all my Things,
for my Father to Break in Pieces ?

Sir Rich. Valeria, Valeria. [*Within.*]

Val. Oh Heav'ns ! Oh Heav'ns ! he is coming up the
Back-stairs. What shall we do ?

 Love-

Lovely. Humph, ha, cann't you put me in that Cloſet there?

Val. Oh no, I han't the Key.

Lovely. I'll run down the Great Stairs, let who will ſee me. [*Going.*]

Val. Oh no, no, no, no, not for your Life;——here, here, here, get under this Tub.

Sir, I'm here. { *Throws out ſome Fiſh in Haſt,* *and Turns the Tub over him.* }

Enter Sir Richard.

Sir Richard. What, at your Whims—and Whirligigs, ye Baggage? I'll out at Window with them.

[*Throwing away the Things.*]

Val. Oh Dear Father, ſave my *Lumbricus Latus.*

Sir Rich. I'll Lamprey and Latum you; what's that I wonder? Ha? Where the Devil got you Names that your Father don't underſtand? Ha? [*Treads upon them.*]

Val. Oh my poor Worm! Now have you deſtroy'd a Thing, that, for ought I know, *England* cann't produce again.

Sir Rich. What is it good for? Anſwer me that?——— VVhat's this Tub here for? Ha? [*Kicks it.*]

Val. What ſhall I do now?——— it is, a 'tis a——— Oh Dear Sir! Don't touch the Tub,——— for there's a Bear's Young Cub that I have brought for Diſſection; but I dare not touch it till the Keeper comes.

Sir Rich. I'll Cub you, and Keeper you, with a Vengeance to you; is my Money laid out in Bears Cubs?——— I'll drive out your Cub.———

{ *Opens the Door, ſtands at a Diſtance off, and* *with his Cane, lifts up the Tub,* Lovely *riſes.* }

Lovely. Oh the Devil diſcover'd, your Servant Sir. [*Exit*]

Sir Rich. Oh! your Servant Sir——— What is this your Bear's Cub? Ha Miſtreſs? His Taylor has lick'd him

into

nto Shape I find.— What did this Man do here ? Ha Huſwife ?——— I doubt you have been ſtudying Natural Philoſophy with a Vengeance.

Val. Indeed, Sir, he only brought me a ſtrange Fiſh, and hearing your Voice I was afraid you ſhould be Angry, and ſo that made me hide him.

Sir. Rich. A Fiſh,— 'tis the Fleſh I fear ;. I'll have you Married to Night.——— I believe this Fellow was the Beggarly Enſign, who never March'd farther than from *Whitehall* to the *Tower*, who wants your Portion to make him a Brigadier, without ever ſeeing a Battel——Huſwife, ha—— tho' your Philoſophical Cant, with a Murrain to you— has put the Captain out of Conceit, I have a Husband ſtill for you ;— come along, come along, I'll ſend the Servants to clear this Room of your Bawbles,—(*pulls her off*) I will ſo.

Val. But the Servants won't, Old Gentleman, that's my Comfort ſtill.　　　　　　　　　　　　　(*Exit.*)

Re-enter Lovely.

Lov. I'm glad they are gone, for the Duce take me if I cou'd hit the Way out.

Enter Sir James.

Sir James. Ha— Enſign'! luckily met ; I have been Labouring for you, and I hope done you a Piece of Service. Why, you look ſurpriz'd.

Lov. Surpriz'd ! ſo wou'd you, Sir *Harry*, if you had been whelm'd under a Tub, without Room to Breath.

Sir James. Under a Tub ! Ha, ha, ha.

Lov. 'Twas the only Place of Shelter.

Sir James. Come, come, I have a better Proſpect, the Cap'ain is a very Honeſt Fellow, and thinks if you can bear with the Girl, you deſerve her Fortune ; here's your
　　　　　　　　　　　　　　　　　　　　　　Part,

Part, [*Gives a Paper*] he'll give you your Cue, he ſtays at his Lodging for you.

Lov. What's the Deſign?

Sir James. That will tell you; quick Diſpatch

Lov. Well, Sir *James*, I know you have a Prolifick Brain, and will rely on your Contrivances, and if it ſucceeds the Captain ſhall have a Bowl of Punch large enough to ſet his Ship afloat. [*Exit*]

Lady Reveller, *Lady* Lucy, *Mrs.* Sago, *appear.*

Sir James. The Tea-Table broke up already! I fear there has been but ſmall Recruits of Scandal to Day.

Mrs. Sago. Well, I'll ſwear I think the Captain's a Plea-ſant Fellow.

Sir James. That's becauſe he made his Court to her.
 [*Aſide*]

Lady Revel. Uh—— I Nauſeate thoſe Amphibious Creatures.

Sir James. Umph, ſhe was not Addreſs'd to.

Lady Lucy. He ſeems neither to want Senſe, Honour, nor True Courage, and methinks there is a Beauty in his Plain Delivery.

Sir James. There ſpoke Sincerity without Affectation.

Lady Revel. How ſhall we paſs the Afternoon?

Sir James. Aye, Ladies, how ſhall we?

Lady Revel. You here! I thought you had Liſted your ſelf Volunteer under the Captain to Board ſome Prize, you whiſper'd ſo often, and ſneak'd out one after another.

Sir James. Who would give one ſelf the Pains to Cruiſe Abroad, when all one Values is at Home?

Lady Revel. To whom is this Directed? Or will you Mo-nopolize and Ingroſs us all?

Sir James. No,— tho', it would wake Deſire in every Beholder, I reſign you to my Worthy Friend.

F *Lady*

Lady Lucy. And the reſt of the Company have no Pretence to you.

Mrs. Sago. That's more than ſhe knows. [*Aſide.*]

Sir James. Beauty, like yours, wou'd give all Mankind Pretence.

Mrs. Sago. So, not a Word to me; are theſe his Vows? [*In an uneaſie Air.*]

Lady Lucy. There's One upon the Teaze already. [*Aſide.*]

Lady Revel. Why, you are in Diſorder, my Dear; you look as if you had loſt a *Trant-Leva :* What have you ſaid to her, Sir *James ?*

Sir James. I ſaid, Madam? I hope I never ſay any Thing to offend the Ladies. The Devils in theſe Married Women, they cann't conceal their own Intriegues, though they Swear us to Secrecy. [*Aſide.*]

Lady Lucy. You miſtake, Couſin, 'tis his ſaying nothing to her has put her upon the Fret.

Lady. Revel. Ah, your Obſervations are always Malicious.

Mrs. Sago. I deſpiſe them, Dear Lady *Reveller,* let's in to Picquet; I ſuppoſe Lady *Lucy* would be pleas'd with Sir *James* alone to finiſh her Remarks.

Lady Lucy. Nay, if you remove the Cauſe, the Diſcourſe ceaſes.

Sir James. [*Going up to her.*] This you draw upon your ſelf, you will diſcover it. [*To her.*]

Mrs. Sago. Yes, your Falſhood.

Lady Revel. Come my Dear, Sir *James,* will you make One at a Pool?

Sir James. Pardon me, Madam, I'm to be at *White's* in Half an Hour, anon at the *Baſſet-Table.* I'm Yours.

Mrs. Sago. No, no, he cann't leave her. [*Going, ſtill looking back*]

Lady Lucy. They play Gold, Sir *James.*

Sir

Sir James. [*Going up to Lady* Lucy] Madam, were your Heart the Stake I'd Renounce all Engagements to win that, or retrieve my own.

Lady Lucy. I muſt like the Counterſtake very well er'e I play ſo high.

Mrs. Sago. Sir *James*, hearkee, One Word with you.

{ *Breaking from Lady* Reveller's *Hand,* }
{ *pulling Sir* James *by the Sleeve.* }

Lady Lucy. Ha, ha, I knew ſhe could not ſtir; I'll re-move your Conſtraint, but, with my wonted Freedom, will tell you plainly———— your Husband's Shop wou'd better become you than Gaming and Gallants. Oh Shame to Virtue, that we ſhou'd Copy Men in their moſt Reigning Vices!

Of Virtue's wholeſome Rules unjuſtly we complain,
When Search of Pleaſures gives us greater Pain.
How ſlightly we our Reputation Guard,
Which loſt but once can never be Repair'd.

Lady *Revel.* Farewel Sentences.

Enter Alpiew.

Alp. Madam———— [*Whiſpers her Lady.*]

Mrs. *Sago.* So then, you'd perſuade me 'twas the Care of my Fame.

Sir *Harry.* Nothing elſe I proteſt, my Dear little Rogue; I have as much Love as you, but I have more Conduct.

Mrs. *Sago.* Well, you know how ſoon I forgive you your Fault.

Sir *James.* Now to what Purpoſe have I Lied my ſelf in-to her good Graces, when I would be glad to be rid of her ? [*Aſide.*]

Lady *Revel.* Booted and Spurr'd ſay you? Pray ſend him

F ?

up,

up, Sir *James* ; I ſuppoſe Truſty *Buckle* is come with ſome
Diverting Embaſſy from your Friend.

Enter Buckle *in a Riding Dreſs.*

Mr. *Buckle.* Why in this Equipage ?

Buckle. Ah ! Madam.———

Lady *Revel.* Out with it.

Buckle. Farewel Friends, Parents, and my Country ; thou
Dear Play-houſe, and ſweet Park, Farewel.

Lady *Revel.* Farewel, why, whither are you going ?

Buckle. My Lord and I am going where they never knew
Deceit.

Sir *James.* That Land is Inviſible, *Buckle.*

Lady *Revel.* Ha, ha, ha.

Sir *James.* Were my Lord of my Mind your Ladiſhip
ſhould not have had ſo large a Theme for your Mirth. Your
Servant Ladies. [*Exit.*]

Lady *Revel.* Well, but what's your Buſineſs?

Buckle. My Lord charg'd me in his Name to take his
Everlaſting Leave of your Ladiſhip.

Lady *Revel.* Why, where is he a going pray ?

Buckle. In ſearch of a Country where there is no Women.

Mrs. *Sago.* Oh dear, why what have the Women done
to him pray?

Buckle. Done to him, Madam ? He ſays they're Proud,
Perfidious, Vain, Inconſtant, Coquets in *England.*

Mrs. *Sago.* Oh ! He'll find they are every where the ſame.

Lady *Revel.* And this is the Cauſe of his Whimſical
Pilgrimage ? Ha, ha.

Buckle. And this proceeds from your ill Uſage, Madam ;
when he left your Houſe,——— he flung himſelf into his
Coach with ſuch a Force, that he broke all the Windows, ———
as they ſay,——— for my Part I was not there,——— when
he came Home he beat all his Servants round to be Re-
veng'd.

Alp. Was you there, *Buckle?*

Buckle. No, I thank my Stars, when I arriv'd the Expedition was over;——— in Haſte he Mounted his Chamber,——— ſlung himſelf upon his Bed,——— Burſting out into a Violent Paſſion,—— Oh that ever I ſhould ſuffer my ſelf to be impos'd upon, ſaid he, by this Coquetiſh Beauty!

Lady Revel. Meaning me, *Buckle,* Ha, ha?

Buckle. Stay till I have·finiſh'd the Piece, Madam, and your Ladiſhip ſhall judge;——— ſhe's as Fickle as ſhe's Fair,——— ſhe does not uſe more Art to Gain a Lover, ſaid he, than to deceive him when he is fix'd.——— Humph.

[Leering at her.]

Lady Revel. Pleaſant——— and does he call this taking Leave?

Mrs. Sago. A Comical Adieu.

Buckle. Oh, Madam, I'm not come to the Tragical Part of it yet, ſtarting from his Bed.——

Lady Revel. I thought it had been all Farce, --- if there be any Thing Heroick in't I'll ſet my Face and look Grave.

Buckle. My Relation will require it, Madam, for I am ready to weep at the Repetition: Had you but ſeen how often he Travaſt the Room, *[Acting it]* heard how often he ſtamp'd, what diſtorted Faces he made, caſting up his Eyesthu, Biting his Thumbs thus.

Lady Revel. Ha, ha, ha, you'll make an Admirable Actor,- - ſhall I ſpeak to the Patentees for you?

Mrs. Sago But pray how did this end?

Buckle. At laſt, Madam, quite ſpent with Rage, he ſunk down upon his Elbow, and his Head fell upon his Arm.

Lady Revel. What, did he faint away?

Buckle. Oh, no.

Mrs. Sago. He did not die?

Buckle. No, Madam, but he fell aſleep.

Lady Revel. Oh Brave Prince *Prettiman.*

Omnes. Ha, ha, ha.

Buckle. After Three Hours Nap he Wak'd————and calling haſtily————my Dear *Buckle,* ſaid he, let's to the End of the World; and try to find a Place where the Sun Shines not here and there at one Time———— for 'tis not fit that it ſhould at once look upon Two Perſons whoſe Sentiments are ſo Different———— She no longer regards my Pain, Ungrateful, Falſe, Inhumane, Barbarous Woman.

Lady Revel. Foolith, Fond, Believing, Eaſie Man; there's my Anſwer————Come, ſhall we to *Piquet,* my Dear ?

Buckle. Hold, hold, Madam, I han't half done————

Mrs. Sago. Oh! Pray my Dear Lady *Reveller,* let's have it out, 'tis very Diverting————

Buckle. He call'd me in a feeble Voice; *Buckle,* ſaid he, bring me my little *Scrutore* ———— for I will write to Lady *Reveller* before I part from this Place, never to behold her more———— what, don't you Cry, Madam ?

Lady Revel. Cry——— No, no, go on, go on.

Buckle. 'Tis done, Madam —— and there's the Letter.
[*Gives her a Letter.*]

Lady Revel. So, this Compleats the Narration. [*Reads.*]
Madam, *Since I cannot Live in a Place where there is a Poſſibility of ſeeing you without Admiring, I reſolve to Fly; I am going for* Flanders; *ſince you are Falſe I have no Buſineſs here*————*I need not deſcribe the Pain I feel, you are but too well Acquainted with that*———— *therefore I'll chuſe Death rather than Return.*————*Adieu.*

Buckle. Can any Man in the World write more Tenderly, Madam? Does he not ſay 'tis Impoſſible to Love you, and go for *Flanders ?* And that he would rather hear of your Death then Return ————

Lady Revel. Excellent, Ha, ha.

Buckle. What, do you Laugh ?

Mrs. Sago. Who can forbear ?

Buckle. I think you ought to Die with Grief; I warrant Heaven will puniſh you all [*Going.*]

Mrs.

Mrs. *Alp.* But hearke'e, *Buckle,* wheie are you going now?

Buckle. To tell my Lord in what Manner your Lady re-ceiv'd his Letter; Farewel ——— now for *Flanders.* ——

Mrs. Alp. A fair Wind, and a good Voyage to you.

[*As he goes out enter Lord* Worthy.]

Buckle. My Lord, here? So' now may I have my Head Broke for my long Harangue if it comes out.

Lady Revel. Oh! Miraculous ——— my Lord, you have not finiſh'd your Campaign already, have you? Ha, ha, ha; or has the *French* made Peace at hearing of your Lordſhip's intended Bravery, and left you no Enemies to Combate?

Lord. My worſt of Foes are here —— here, within my Breaſt; your Image, Madam.

Lady Revel. Oh Dear, my Lord, no more of that Theme, for *Buckle* has given us a Surfeit on't already —— even from your Breaking the Glaſſes of your Coach —— to your falling faſt Aſleep. Ha, ha, ha.

Lord. The Glaſſes of my Coach! What do you mean, Ma-dam---- Oh Hell! [*Biting his Thumbs.*]

Buckle. Ruined quite. ——— Madam, for Heavens ſake what does your Ladiſhip Mean? I Li'd in every Syllable I told you, Madam.

Lady. Nay, if your Lordſhip has a Mind to Act it over agen we will Oblige you for once ———*Alpiew* ſet Chairs---- ---come, Dear *Sago,* ſit down ——and let the Play begin— ---*Buckle* knows his Part, and upon Neceſſity cou'd Act yours too my Lord.

Lord. What has this Dog been doing? When he was only to deliver my Letter, to give her new Subject for her Mirth——--Death, methinks I hate her,—— Oh that I cou'd hold that Mind —— what makes you in this Equipage? Ha! Sirrah? [*Aſide.*]

Buckle. My Lord, I, I, I, I,

Lord. Peace Villain———- [*Strikes him.*]

Lady.

Lady. Hey —— this is Changing the Scene—

Buckle. Who the Devil would Rack his Brains for theſe People of Quality, who like no Body's Wit but their own ?—— [*Aſide.*]

Mrs. Sago. If the Beating were Invention before, thou haſt it now in Reality; if Wars begin I'll Retire. They may agree better alone perhaps. [*Exit.*]

Lady. Where did you learn this Rudeneſs, my Lord, to Strike your Servant before me ?

Lord. When you have depriv'd a Man of his Reaſon how can you blame his Conduct ?

Buckle. Reaſon —— Egad —— there's not Three Drams of Reaſon between you both ---- as my Cheek can teſtifie. [*Aſide.*]

Lady. The Affront was meant to me ---- nor will I endure theſe Paſſions —— I thought I had forbid your Viſits.

Lord. I thought I had Reſolv'd againſt them to.

Alpiew. But Reſolutions are of ſmall force of either ſide. [*Aſide.*]

Lord. Grant me but this One Requeſt and I'll remove this hated Object.

Lady. Upon Condition 'tis the laſt.

Lord. It ſhall —— I think it ſhall at leaſt —— Is there a Happy Man for whom I am Deſpiſed ?

Lady. I thought 'twas ſome ſuch ridiculous Queſtion; I'm of the *Low-Church*, my Lord, conſequently hate Confeſſors; ha, ha, ha.

Buckle. And Penance to I dare Swear. [*Aſide.*]

Lord. And every thing but Play.

Lady. Dare you, the Subject of my Power —— you, that Petition Love, Arraign my Pleaſures? Now I'm ſixt —— and will never ſee you more.

Buckle. Now wou'd any Body Swear ſhe's in Earneſt.

Lord. I cannot bear that Curſe —— ſee me at your Feet again, (*Kneels*) Oh ! you have Tortui'd me enough,

take

take Pity now Dear Tyrant, and let my Suffering end.

Lady. I muſt not be Friends with him, for then I ſhall have him at my Elbow all Night, and ſpoil my Luck at the *Baſſet-Table.* [*Aſide.*] Either Cringing or Correcting, always in Extreams ———— I am weary of this Fatigue.

He that wou'd gain my Heart muſt Learn the Way
Not to Controul, but readily to Obey.
For he that once Pretends my Faults to ſee,
That Moment makes himſelf all Faults to me.

[*Exit.*]

Buckle. There's the Inſide of a Woman. [*Aſide.*]
Lord. Gon————now Curſes on me for a Fool————
the worſt of Fools———— a Woman's Fool————

Whoſe only Pleaſure is to feed her Pride,
Fond of her Self, ſhe cares for none beſide.
So true Coquets on their numerous Charms Diſplay,
And ſtrive to Conquer on purpoſe to betray.

ACT. III.

Enter Lord Worthy *and* Sir James.

Sir James. Well, my Lord. I have left my Cards in the Hand of a Friend to hear what you have to ſay to me. Love I'm ſure is the Text, therefore Divide and Subdivide as quick as you can.

G

Lord.

Lord. Coud'ſt thou Infuſe into me thy Temper, Sir *James*, I ſhou'd have thy Reaſon too; but I am Born to Love this Fickle, Faithleſs Fair —— what have I not Eſſay'd to Race her from my Breaſt? But all in Vain; I muſt have her, or I muſt not Live.

Sir James. Nay, if you are ſo far gone, my Lord, your Diſtemper requires an Able Phyſician —— what think you of *Loveley*'s bringing a File of Muſcqueteers, and carry her away, *Via & Armis?*

Lord. That Way might give her Perſon to my Arms, but where's the Heart?

Sir James. A Trifle in Competition with her Body.

Lord. The Heart's the Gem that I prefer.

Sir James. Say you ſo my Lord? I'll Engage Three Parts of *Europe* will make that Exchange with you; Ha, ha, ha.

Lord. That Maxim wou'd hold with me perhaps in all but her, there I muſt have both or none; therefore Inſtruct, me Friend, thou who negligent in Love, keeps always on the Level with the Fair —— what Method ſhou'd I take to Sound her Soul's Deſign? For tho' her Carriage puts me on the Rack when I behold that Train of Fools about her, yet my Heart will plead in her Excuſe, and Calm my Anger Spite of all Efforts.

Sir James. Humph? I have a Plot, my Lord, if you'll comply with it.

Lord. Nothing of Force.

Sir James. Whate're it be you ſhall be Witneſs of it, 'twill either Quench your Flame, or Kindle hers. I only will appear the Guilty; but here's Company, I'll tell you all within.

Enter Captain *and* Lovely *Dreſt like a Tar.*

Lord. I'll expect you. [*Exit.*]

Sir James. Ha, Captain, How ſits the Wind between you and your Miſtreſs? Ha? *Capt.*

Capt. North and by South, Faith ; but here's one Sails full Eaſt, and without ſome unexpected Tornado, from the Old Man's Coaſt ———— he makes his Port I warrant ye.

Lovely. I wiſh I were at Anchor once.

Sir James. Why, thou art as arrant a Tar as if thou hadſt made an *Eaſt-India* Voyage, ha, ha.

Lovely. Ay, am I not, Sir *James ?* But Egad I hope the Old Fellow underſtands nothing of Navigation ; if he does I ſhall be at a loſs for the Terms.

Sir James. Oh ! no matter for Terms ———— look big, and Bluſter for your Country ——— deſcribe the *Vigo* Buſineſs ——— publick News will furniſh you with that, and I'll engage the Succeſs.

Capt. Ay, Ay, let me alone, I'll bear up with Sir *Richard,* and thou ſhalt Board his Pinnace with Conſent ne'er fear.—— ho, here he comes full Sail.

Enter Sir Richard.

Sir Richard. I'm glad to ſee you ; this is my Kinſman which I told you of, as ſoon as he Landed ; I brought him to Kiſs your Hands.

Sir Rich. I Honour you, you are welcome.

Lovely. I thank you Sir, ————I'm not for Compliments ; 'tis a Land Language I underſtand it not ; Courage, Honeſty, and Plain-dealing Truth, is the Learning of our Element ; if you like that I am for ye.

[Aſide to the Captain.]

Sir James. The Rogue does it to a Miracle.

Capt. He's an improving Spark I find, ha, ha.

Sir James. Like it, Sir , why 'tis the only Thing I do like, hang Compliments, and Court-Breeding , it ſerves only to make Men a Prey to one another, to Encourage Cowardice, and Ruin Trade———No, Sir, give me the Man that dares meet Death and Dinner with the ſame Appe-

tite——

tite—one who rather than let in Popery, wou'd let out his Blood; to Maintain ſuch Men I'd pay Double Cuſtom; nay, all my Gain ſhou'd go for their Support. Captain lanch off a round Lie or Two.　　　　[*Aſide to the Enſign.*]

Sir James. The beſt Well-wiſher to his Country of an *Engliſhman* I ever heard.

Lovely. Oh, Sir *Richard,* I wiſh the Nation were all of your Mind, 'twou'd give the Soldiers and the Sailors Life.

Capt. And make us Fight with Heart and Hand; my Kinſman, I'll aſſure you, 'tis your Principle to a Hair; he hates the *French* ſo much he ne'er fails to give them a Broad-ſide where'er he meets them; and has Brought in more Privateers this War than half the Captains in the *Navy;* he was the firſt Man that Boarded the *French Fleet* at *Vigo* ----and in *Gibraltar* Buſineſs——the *Gazettes* will inform you of the Name of Captain *Match.*

Sir James. Is this that Captain *Match?*

Lovely. For want of better, Sir.

Sir James. Sir, I ſhall be Proud of being known to you.

Sir Rich. And I of being Related to you, Sir,——— I have a Daughter Young and Handſome, and I'll give her a Portion ſhall make thee an Admiral Boy; for a Soul like thine is fit only to Command a Navy ——what ſay'ſt thou, art thou for a Wife?

Sir James. So, 'tis done, ha, ha, ha.　　　　[*Aſide*]

Capt. A proſperous Gale I'faith.

Lovely. I don't know, Sir *Richard,* mehap a Woman may not like me; I am Rough and Storm-like in my Temper, unacquainted with the Effeminacy of Courts; I was Born upon the Sea, and ſince I can remember never Liv'd Two Months on Shore; if I Marry my Wife muſt go Abroad, I promiſe you that.

Sir Rich. Abroad Man? Why ſhe ſhall go to the *Indies* with the———Oh! ſuch a Son-in-Law ——how ſhall I be Bleſt in my Poſterity? Now do I foreſee the Greatneſs of

my

my Grand Children; the Sons of this Man fhall, in the Age to come, make *France* a Tributary Nation.

Lovely. Once in an Engagement, Sir, as I was giving Orders to my Men, comes a Ball and took off a Fellow's Head, and ftruck it full in my Teeth; I wipp'd it up, clapp'd it into a Gun, and fhot it at the Enemy again.

Sir Rich. Without the leaft Concern?

Lovely. Concern, Sir,—— ha, ha, ha, if it had been my own Head I would have done the like.

Sir Richard. Prodigious Effect of Courage!—— Captain I'll fetch my Girl, and be here again in an Inftant:—— What an Honour 'twill be to have fuch a Son! [*Exit.*]

Capt. Ha, ha, ha, ha, you outdo your Mafter.

Sir James. Ha, ha, ha, ha, the Old Knight's Tranfported.

Lovely. I wifh 'twas over, I am all in a Sweat; here he comes again.

Enter Sir Richard *and* Valeria.

Sir Rich. I'll hear none of your Excufes,—— Captain your Hand,—— there take her,—— and thefe Gentlemen fhall be Witneffes, if they pleafe, to this Paper, wherein I give her my whole Eftate when I die, and Twenty Thoufand Pounds down upon the Nail; I care not whether my Boy be worth a Groat,—— get me but Grandfons and I'm Rich enough.

Capt. Generoufly faid I'faith—— much Good may do him with her.

Lovely. I'll do my Eedeavour, Father, I promife you.

Sir James. I wifh you Joy, Captain, and you, Madam.

Val. That's Impoffible;—— can I have Joy in a Species fo very different from my own? Oh my Dear *Lovely*!—— We were only form'd one for another;—— thy Dear Enquiring Soul is more to me—— than all thefe ufelefs Lumps of Animated Clay: Duty compels my Hand,— but my Heart is fubject only to my Mind,——

the

the Strength of that they cannot Conquer;——— no, with the Resolution of the Great Unparallell'd *Epictetus*,——— I here protest my Will shall ne're assent to any but my *Lovely*.

Sir *Richard*. Ay, you and your Will may Philosophize as long as you please,——— Mistress,——— but your Body shall be taught another Doctrine,——— it shall so,——— Your Mind,——— and your Soul, quotha! Why, what a Pox has my Estate to do with them? Ha? 'Tis the Flesh Huswife, that must raise Heirs,——— and Supporters of my Name;——— and since I knew the getting of the Estate, 'tis fit I shou'd dispose of it,——— and therefore no more Excuses, this is your Husband do you see,——— take my Word for it.

Val. *The outward empty Form of Marriage take*
But all beyond I keep for Lovely's *Sake.*
Thus on the Ground for ever fix my Eyes;
All Sights but Lovely *shall their Balls despise.*

Sir *Rich*. Come, Captain,———my Chaplain is within, he shall do the Business this Minute: If I don't use the Authority of a Father, this Baggage will make me lose such a Son-in-law that the City's Wealth cann't purchase me his Fellow. [*Aside.*]

Lovely. *Thanks Dear Invention for this Timely Aid.*
The Baits gon down, he's by himself betray'd.
Thus still where Arts both True and Honest fail,
Deceitful Wit and Policy prevail.

Val. To Death, or any Thing,——— 'tis all alike to me.
[*Exit cum Valeria.*]
Sir *Rich*. Get you in I say,——— Hussey, get you in. In my Conscience my Niece has spoil'd her already; but I'll have her Married this Moment; Captain, you have bound

me ever to you by this Match, command me and my Houſe for ever.———— But ſhall I not have your Company, Gentlemen, to be Witneſſes of this Knot, this joyful Knot?

Capt. Yes Faith, Sir *Richard*, I have too much Reſpect for my Kinſman to leave him— till I ſee him ſafe in Harbour; Ill wait on you preſently.

Sir James. I am engag'd in the next Room at Play, I beg your Pardon, Sir *Richard*, for an Hour; I'll bring the whole Company to Congratulate the Bride and Bridegroom.

Sir Rich. Bride and Bridegroom? Congratulate me, Man: Methinks I already ſee my Race Recorded amongſt the foremoſt Heroes of my Nation.—— Boys, all Boys,— and all Soldiers.

They ſhall the Pride of France *and* Spain *pull down,*
And add their Indies *to our* Engliſh *Crown.* [*Exit.*]

Sir James. Ha, ha, ha, never was Man ſo Bigotted before;———— how will this end when he diſcovers the Cheat? Ha, ha, won't you make One with the Ladies, Captain?

Capt. I don't care if I do venture a Piece or Two, I'll but diſpatch a little Buſineſs and meet you at the Table, Sir *James.* [*Exit.*]

Enter Lady Lucy.

Sir James. Ha, Lady *Lucy!* Is your Ladiſhip reconccil'd to *Baſſet* yet? Will you give me leave to loſe this Purſe to you, Madam?

Lady Lucy. I thank Fortune I neither wiſh, nor need it, Sir *James*; I preſume the next Room is furniſh'd with Avarice enough to ſerve you in that Affair, if it is a Burden to you; or Mrs. *Sago's* ill Luck may give you an Opportunity of returning ſome of the Obligations you lye under.

Sir James. Your Sex, Madam, extorts a Duty from ours,
and

and a well-bred Man can no more refuse his Money to a Lady, than his Sword to a Friend.

Lady *Lucy*. That Superfluity of good Manners, Sir *James*, would do better Converted into Charity; this Town abounds with Objects ——— wou'd it not leave a more Glorious Fame behind you to be the Founder of some Pious Work; when all the Poor at mention of your Name shall Bless your Memory; than that Posterity shou'd say you Wasted your Estate on Cards and Women?

Sir *James*. Humph, 'tis pity she were not a Man, she Preaches so Emphatically. [*Aside.*] Faith, Madam, you have a very good Notion, but something too Early——when I am Old, I may put your Principles in Practice, but Youth for Pleasure was design'd——

Lady *Lucy*. The truest Pleasure must consist in doing Good, which cannot be in Gaming.

Sir *James*. Every thing is good in its Kind, Madam; Cards are harmless Bits of Paper, Dice insipid Bones—and Women made for Men.

Lady *Lucy*. Right, Sir *James* ——— but all these things may be perveted ——— Cards are harmless Bits of Paper in themselves, yet through them what Mischiefs have been Done? What Orphans Wrong'd? What Tradesmen Ruin'd? What Coach and Equipage dismist for them?

Sir *James*. But then, how many fine Coaches and Equipages have they set up, Madam?

Lady *Lucy*. Is it the more Honourable for that? How many Misses keep Coaches too? Which Arrogance in my Opinion only makes them more Eminently Scandalous——

Sir *James*. Oh! t'ose are such, as have a Mind to be Damn'd in this State, Madam——but I hope your Ladiships don't Rank them amongst us Gamesters.

Lady *Lucy*. They are Inseparable, Sir *James*; Madam's Grandeur must be Upheld —— tho' the Baker and Butcher shut up Shop.

Sir *James.* Oh ! your Ladiſhip wrongs us middling Gentlemen there ; to Ruin Tradeſmen is the Qualities Prerogative only ; and none beneath a Lord can pretend to do't with an Honourable Air, ha, ha.

Lady *Lucy.* Their Example ſways the meaner Sort ; I grieve to think that Fortune ſhou'd Exalt ſuch Vain, ſuch Vitious Souls————whilſt Virtue's Cloath'd in Raggs.

Sir *James.* Ah ! Faith, ſhe'd make but a ſcurvy Figure at Court, Madam, the Stateſ-men and Politcians wou'd Suppreſs her quickly ———— but whilſt ſhe remains in your Breaſt ſhe's ſafe —— and makes us all in Love with that Fair Covering.

Lady *Lucy.* Oh! Fie, Fi, Sir *James,* you cou'd not Love one that hates your chief Direction.

Sir *James.* I ſhou'd Hate it too, Madam, on ſome Terms that I cou'd Name.

Lady *Lucy.* What wou'd make that Converſion pray ?

Sir *James.* Your Heart.

Lady *Lucy.* I cou'd pay that Price———— but dare not Venture upon one ſo Wild ———— [*Aſide.*] Firſt let me ſee the Fruit e'er I take a Leaſe of the Garden, Sir *James.*

Sir *James.* Oh ! Madam, the beſt Way is to Secure the Ground, and then you may Manure and Cultivate it as you pleaſe.

Lady *Lucy.* That's a certain Trouble and uncertain Profit. and in this Affair ; I prefer the Theory before the Practick. But I detain you from the Table, Sir *James*———— you are wanted to Tally————your Servant———— [*Exit.*]

Sir *James.* Nay, if you leave me, Madam, the Devil will Tempt me————ſhe's gone, and now cann't I ſhake off the Thought of Seven Wins, Eight Loſes ———— for the Blood of me———and all this Grave Advice of hers is loſt, Faith———— tho' I do Love her above the reſt of her Sex———ſhe's an exact Model of what all Women ought to be,———and yet your Merry little Coquetiſh Tits are very Diverting———— well, now for *Baſſet* ; let me ſee what Money have I about me Humph about a Hundred *Guineas*———half of which will ſet the Ladies to Cheating———falſe Parolies in Abundance. H *Each*

Each Trifling Toy wou'd Tempt in Times of Old,
Now nothing, Melts a Womans Heart like Gold.
Some Bargains Drive, other's more Nice then they,
Who'd have you think they Scorn to Kifs for Pay;
To Purchase them you muft Lofe Deep at Play.
With feveral Women, feveral Ways Prevail;
But Gold's a certain Way that cannot Fail. [Exit.]

The Scence Draws, and Difcovers Lady Reveller, *Mrs.* Sago, *and feveral Gentlemen and Ladies round a Table at Baffet.*

Enter Sir James.

Lady Revel. Oh! Sir *James*, are you come? We want you to Tally for us.

Sir James. What Luck, Ladies?

Lady Revel. I have only won a *Sept & Leva.*

Mrs. Sago. And I have loft a *Trante & Leva*——my Ill Fortune has not forfook me yet I fee.

Sir James. I go a *Guinea* upon that Card.

Lady Revel. You lofe that Card.

Mrs. Sago. I Mace Sir *James's* Card Double.

Banker. Seven wins, and Five lofes; you have loft it, Madam.

Mrs. Sago. Agen?——fure never was Woman fo Unlucky--

Banker. Knave wins, and Ten lofes; you have Won, Sir *James.*

Lady Revel. Clean Cards here.

Mrs. Sago. Burn this Book, 'thas an unluckly Air. (*Tears them.*) Bring fome more Books.

Enter Captain.

Lady Revel. Oh! Captain—— here fet a Chair, come, Captain you, fhall fit by me —— now if we can but Strip this Tarr. [*Afide*]

Capt. Withal my Heart, Madam—— come, what do you Play Gold? —— that's fomething High tho'----- well a *Guinea* upon this Honeft Knave of Clubs.

Lady Revel. You lofe it for a *Guinea* more.

 Capt.

Capt. Done, Madam.

Banker. The Five Wins, and the Knave loſes.

Lady. Revel. You have loſt it, Captain.

Sir James. The Knave wins, for Two Guineas more, Madam.

Lady Revel. Done Sir *James.*

Banker. Six Wins——Knave Loſes.

Sir James. Oh! the Devil, I'm Fac't, I had rather have loſt it all.

Banker. Nine wins, Queen loſes —— you have won,

Mrs. Sago. I'll make a Paroli—— I Mace as much more; your Card loſes, Sir *James,* for Two Guineas', your's, Captain, loſes for a Guineas more.

Banker. Four wins, Nine loſes ——, you have Loſt, Madam.

Mrs. Sago. Oh! I cou'd Tear my Fleſh —— as I Tear theſe Cards——— Confuſion —— I can never win above a wretch'd *Paroli*; for if I puſh to *Sept & Leva,* tis gone.
 [*Walks about Diſorderly.*]

Banker. Ace wins, Knave loſes.

Capt. Sink the Knave, I'll ſet no more on't.

Lady Revel. Fac't agen——— what's the meaning of this Ill-luck to Night? Bring me a Book of Hearts, I'll try if they are more Succeſsful, that on the Queen; yours and your Cards loſes.

Mrs. Sago. Bring me a freſh Book; bring me another Book; bring me all Diamonds.

> *Looks upon them One by One, then*
> *throws them over her Shoulders.*

Lady Revel. That can never be lucky, the Name of *Jewel* don't become a Citizen's Wife. [*Aſide.*]

Banker. King wins, the Tray loſes.

Sir James. You have great Luck to Night, Mr. *Sharper.*

Sharper. So I have Sir *James* ——— I have won *Sonica* every time.

Lady Revel. But if he has got the Nack of winning thus he ſhall ſharp no more here, I promiſe him. [*Aſide.*]

Mrs. Sago. I Mace that.

Lady

Lady Revel. Sir *James*, pray will you Tally.

Sir James. With all my Heart, Madam.

 [*Takes the Cards and ſhuffles them.*]

Mrs Sago. Pray give me the Cards, Sir.

 [*Takes 'em and ſhuffles 'em, and gives 'em to him again.*]

Capt. I ſet that.

Lady Revel. I ſet Five Guineas upon this Card, Sir *James.*

Sir James. Done Madam,—— Five wins,—— Six loſes.

Mrs. Sago. I Set that.

Sir James. Five don't go, and Seven loſes.

Capt. I Mace double.

Lady Revel. I Mace that.

Sir James. Three wins, Six loſes.

Mrs. Sago. I Mace, I Mace double, and that—— Oh ye malicious Stars!——— again.

Sir James. Eight wins Seven loſes.

Capt. So, this *Trante & leva* makes ſome Amends ;——— Adsbud I hate Cheating,———What's that falſe Cock made for now ? Ha, Madam ?

Lady Rev. Nay, Mrs. *Sago*, if you begin to play foul.

Mrs Sago. Rude Brūte, to take Notice of the Slight of Hand in our Sex ——— I proteſt he wrongs me, Madam,— there's the *Dernier*, Stake,—— and I'll ſet it all,—— now Fortune Favour me, or this Moment is my laſt.

Lady Revel. There's the laſt of Fifty Pounds,— what's the Meaning of this ?

Sir James. Now for my Plot, her Stock is low I perceive. [*Slips a Purſe of Gold into the Furbeloes of Lady* Reveller's *Apron.*]

Lady Revel. I never had ſuch ill Luck,--- I muſt fetch more Money: Ha ; from whence comes this ? This is the Genteeleſt Piece of Gallantry, the Action is Sir *Harry's*, I ſee by his Eyes. { *Diſcovers a Purſe in the* }
 { *Furbeloes of her Apron.* }

Sir James. Nine wins, Six loſes

Mrs. Sago. I am ruin'd and undone for ever ; oh, oh, oh, to looſe every Card, oh, oh, ho. [*Burſt out a Crying.*]

Capt. So there's one Veffel fprung aleek, and I am almoft afhoar—— If I go on at this Rate, I fhall make but a lame Voyage on't I doubt.

Sir James. Duce wins, King lofes.

Capt. I Mace again,——I Mace Double, I mace again;——now the Devil blow my Head off if ever I faw Cards run fo; Dam 'em. [*Tears the Cards, and ftamps on 'em.*]

Sir James. Fie, Captain, this Concern among the Ladies is indecent.

Capt. Dam the Ladies,—— mayn't I fwear,——or tear my Cards if I pleafe, I'm fure I have paid for them; pray count the Cards, I believe there's a falfe Tally.

Sir James. No, they are Right, Sir. [*Sir James counts em.*]

Mrs. *Sago.* Not to turn One Card! Oh, oh, oh.
[*Stamps up and down.*]

Lady *Revel.* Madam, if you play no longer pray don't difturb thofe that do.--Come, Courage, Captain,-- Sir *James's* Gold was very lucky;—— who cou'd endure thefe Men did they not lofe their Money? [*Afide.*]

Capt. Bring another Book here;—— that upon Ten,—— and I Mace that.—— [*Puts down a Card, and turns another.*]

Sir James. King face't, Eight wins, Ten lofes.

Capt. Fire and Gunpowder. [*Exit.*]

Lady *Revel.* Ha, ha, ha, what is the Captain vanifh'd in his own Smoak?—Come, I Bett with you, Mr. *Sharper*; your Card lofes.

Re-enter Captain, pulling in a Stranger, which he had fetch'd out of the Street.

Capt. Sir, do you think it poffible to lofe a *Trante & Leva* a *Quinfe-leva*,— and a *Sept-et-leva*,—— and never turn once, *Stranger.* No fure, 'tis almoft Impoffible.

Cap. Uunds you lie, I did Sir. [*Laying his Hand on his Sword.*]

Lady *Revel.* and ⎱ Ah, ah.
all the Women. ⎰ Ah, ah. [*Shrieks and run off.*]

Captain. What the Devil, had I to do among thefe Land-Rats?—— Zounds, to lofe Forty Pounds for nothing, not fo much as a Wench for it; Ladies, quotha,—— a Man had

had as good be acquainted with Pick-pockets. [*Exit.*]

Sir *James.* Ha, ha, ha, the Captain has frighted the Women out of their Wits,—— now to keep my Promiſe with my Lord, tho' the Thing has but an ill Face, no Matter.

They join together to Enſlave us Men,
And why not we to Conquer them again.

ACT. V.

Enter Sir James *on one ſide, and Lady* Reveller *on the other.*

Lady *Revel.* SIR *James*, what have you done with the Rude Porpois?

Sir *James.* He is gone to your Uncle's Apartment, Madam, I ſuppoſe.——I was in Pain till I knew how your Ladiſhip did after your Fright.

Lady *Revel.* Really, Sir *James*, the Fellow has put me into the Spleen by his ill Manners. Oh my Stars! That there ſhould be ſuch an unpoliſhed Piece of Humane Race, to be in that Diſorder for loſing his Money to us Women.—— I was apprehenſiev he would have beat me, ha, ha.

Sir *James.* Ha, ha, your Ladiſhip muſt impute his ill Breeding to the Want of Converſation with your Sex; but he is a Man of Honour with his own, I aſſure you.

Lady *Revel.* I hate out of faſhion'd Honour.—— But where's the Company, Sir *James*? Shan't we play again?

Sir *James.* All diſperſs'd, Madam.

Lady *Revel.* Come, you and I'll go to Picquet then.

Sir *James.* Oh I'm tir'd with Cards, Madam, cann't you think of ſome other Diverſion to paſs a chearful Hour?—— I cou'd tell you One if you'd give me leave.

Lady *Revel.* Of your own Invention? Then it muſt be a pleaſant One.

Sir *James.* Oh the pleaſanteſt one in the World.

Lady *Revel.* What is it I pray?

Sir *James.* Love, Love, my Dear Charmer.

[*Approaches her.*]

Lady

Lady Revel. Oh Cupid! How came that in your Head?

Sir James. Nay, 'tis in my Heart, and except you pity me the Wound is Mortal.

Lady Revel. Ha, ha, ha, is Sir *James* got into my Lord *Worthy's* Claſs?———— You that could tell me I ſhould not have ſo large a Theme for my Diverſion, were you in his Place, ha, ha, ha; what, and is the Gay, the Airy, the Witty, Inconſtant, Sir *James* overtaken? Ha, ha.

Sir James. Very true, Madam,——— you ſee there is no jeſting with Fire.——— Will you be kind?
 [*Gets between her and the Door.*]

Lady Revel. Kind? What a diſmal Sound was there?— I'm afraid your Feaver's high, Sir *James*, ha, ha.

Sir James. If you think ſo, Madam, 'tis time to apply cooling Medicines. [*Locks the Door.*]

Lady Revel. Ha, what Inſolence is this? The Door lock'd! What do you mean Sir *James*?

Sir James. Oh 'tis ſomething indecent to Name it, Madam, but I intend to ſhow you. [*Lays hold on her.*]

Lady Revel. Unhand me, Villain, or I'll cry out.———

Sir James. Do, and make your ſelf the Jeſt of Servants, expoſe your Reputation to their vile Tongues,———which if you pleaſe ſhall remain ſafe within my Breaſt; but if with your own Noiſe you Blaſt it, here I bid Defiance to all Honour and Secrecy,——— and the Firſt Man that enters dies.
 [*Struggles with her.*]

Lady Revel. What ſhall I do? Inſtruct me Heaven— Monſter, is this your Friendſhip to my Lord? And can you wrong the Woman he Adores.

Sir James. Ay, but the Woman does not care a Souſe for him; and therefore he has no Right above me; I love you as much, and will poſſeſs.

Lady Revel. Oh! hold——Kill me rather than deſtroy my Honour —— what Devil has Debauch'd your Temper? Or how has my Carriage drawn this Curſe upon me? What have I done to give you cauſe to think you ever ſhou'd ſucceed this hated Way. [*Weeps.*]

Sir James. Why this Queſtion, Madam? Can a Lady
 that

that loves Play ſo paſſionately as you do ———— that takes
as much Pains to draw Men in to loſe their Money, as a
Town Miſs to their Deſtruction ———— that Careſſes all
Sorts of People for your Intereſt, that divides your time
between your Toylet and the *Baſſet-Table* ; (can you, I ſay,
boaſt of Innate Virtue ? ———— Fie, fie, I am ſure you muſt
have gueſs'd for what I Play'd ſo Deep ———— we never
part with our Money without Deſign——or writing Fool
upon our Foreheads ;————therefore no more of this Re-
ſiſtance, except you would have more Money.

Lady *Revel.* Oh ! horrid.

Sir *James.* There was Fifty Guineas in that Purſe, Ma-
dam———— here's Fifty more ; Money ſhall be no Diſpute.
[*Offers her Money.*]

Lady *Revel.* [*Strikes it Down.*] Periſh your Money with
your ſelf ———— you Villain—— there, there ; take your
boaſted Favours, which I reſolv'd before to have Repaid
in *Specie* ; Baſeſt of Men I'll have your Life for this Affront---
what ho, within there.

Sir *James.* Huſh———— Faith, you'll Raiſe the Houſe.
[*Lays hold on her.*] And 'tis in Vain——you are mine ; nor
will I quit this Room till I'm Poſſeſt.　　[*Struggles.*]

Lady *Revel.* Raiſe the Houſe, I'll raiſe the World in
my Defence, help, Murther, Murther, ————a Rape, a
Rape————

Enter Lord Worthy *from another Room with his Sword
Drawn.*

Lord. Ha ! Villain, unhand the Lady———— or this
Moment is thy laſt.

Sir *James.* Villain, Back my Lord ——follow me. [*Exit.*]

Lady *Revel.* By the Bright Sun that Shines you ſhall not
go---no, you have ſav'd my Virtue, and I will preſerve your
Life————let the vile Wretch be puniſh'd by viler Hands---
yours ſhall not be Prophan'd with Blood ſo Baſe, if I have
any Power————

Lord. Shall the Traytor Live ?————Tho' your Barbarous
Uſage does not Merit this from me, yet in Conſideration
that

that I Lov'd you once——— I will Chaſtiſe his Inſolence.

Lady *Revel.* Once ———Oh ! ſay not once ; do you not Love me ſtill ? Oh ! how pure your Soul appears to me above that Deteſted Wretch. [*Weeps.*]

Sir *James.* [*Peeping.*] It takes as I cou'd Wiſh———

Lord. Yet how have I been ſlighted, every Fop preferr'd to me ?—— Now you Diſcover what Inconveniency your Gaming has brought you into—this from me wou'd have been unpardonable Advice——now you have prov'd it at your own Expence.

Lady *Revel.* I have, and hate my ſelf for all my Folly——Oh ! forgive me ———and if ſtill you think me Worthy of your Heart———I here Return you Mine ——— and will this Hour Sign it with my Hand.

Sir *James.* How I Applaud my ſelf for this Contrivance.

Lord. Oh ! the Tranſporting Joy, it is the only Happineſs I Covet here.

Haſte then my Charmer, haſte the long'd-for Bliſs.
The only Happy Minutes of my Life is this. [*Exit.*]

Sir *James.* Ha, ha, ha, ha, how am I Cenſur'd now for doing this Lady a iece of Service, in forcing that upo n her, which only her Vanity and Pride Reſtrain'd.

So Bluſhing Maids refuſe the Courtd Joy,
Tho' wiſhing Eys ———and preſſing Hands Comply,
Till by ſome Stratagem the Lover Gains,
What ſhe deny'd to all his Amorous Pains.

As Sir James *is going off, enter Lady* Lucy *meeting him.*

Sir *James.* Ha, Lady *Lucy !*———Having Succeeded for my Friend, who knows but this may be my Lucky Minute too ?——— Madam, you come Opportunely to hear.
 [*Takes her by the Hand.*]

Lady *Lucy.* Stand off Baſeſt of Men, I have heard too much ; cou'ſt thou Chuſe no Houſe but this to Act thy Villanies in ? And cou'd'ſt thou fairly offer Vows to me, when thy Heart, Poiſon'd with vicious Thoughts, harbour'd this Deſigns againſt my Family ?

Sir *James.* Very fine, Faith, this is like to be my Lucky

I Minute

Minute with a Witneſs ; but Madam——

Lady *Lucy.* Offer not at Excuſes, 'tis height of Impudence to look me in the Face.

Sir *James.* Egad ſhe Loves me——Oh ! Happy Rogue——this Concern can proceed from nothing elſe. [*Aſide.*]

Lady *Lucy.* My Heart till now unus'd to Paſſion ſwells with this Affront, wou'd Reproach thee —————— wou'd Reproach my ſelf, for having Harbour'd one favourable Thought of thee.

Sir *James.* Why did you, Madam ?——Egad I owe more to her Anger than ever I did to her Morals.

Lady *Lucy.* Ha ! What have I ſaid ?

Sir *James.* The only kind Word you ever utter'd.

Lady *Lucy.* Yes, Impoſture, know to thy Confuſion that I did love the,and fancy'd I Diſcover'd ſome Seeds of Virtue amongſt that Heap of Wickedneſs ; but this laſt Action has betray'd the Fond Miſtake, and ſhow'd thou art all o'er Feign'd.

Sir *James.* Give me leave, Madam——

Lady *Lucy.* Think not this Confeſſion meant to advance thy Impious Love, but hear my Final Reſolution.

Sir *James.* Egad I muſt hear it—— I find for there's no ſtopping her.

Lady *Lucy.* From this Moment I'll never ——

Sir *James.* (*Clapping his and before Her Mouth.*) Nay, nay, nay, after Sentence no Criminal is allow'd to Plead ; therefore I will be hear'd——not Guilty, not Guilty. Madam, by ——if I don't prove that this is all a Stratagem, Contriv'd, Study'd, Deſign'd, Proſecuted, and put in Execution, to reclaim your Couſin, and give my Lord Poſſeſſon——may you Finiſh your Curſe, and I Doom'd to Everlaſting Abſence—— Egad I'm out of Breath ——

Lady *Lucy.* Oh ! Cou'dſt thou prove this ?

Sir *James.* I can, if by the Proof you'll make me Happy ; my Lord ſhall Convince you.

Lady *Lucy.* To him I will refer it, on this Truth your Hopes Depend.

In Vain we ſtrive our Paſſions to Conceal,
Our very Paſſions does our Loves Reveal;
When once the Heart, yields to the Tyrants Sway,
The Eyes or Tongue will ſoon the Flame Betray. [*Exit.*]

Sir James. I was never out at a Critical Minute in my Life.
 Enter Mr. Sago *and Two Bailiffs meeting* Alpiew.
 Mrs. Sago. Hearkee, Miſtreſs, is my Wife here?
 Alp. Truly I ſhant give my ſelf the Trouble of ſeeking
her for him; now ſhe has loſt all her Money----your
Wife is a very Indiſcreet Perſon, Sir.
 Mr. Sago. I'm afraid I ſhall find it ſo to my Coſt.
 Bailiffs. Come, come, Sir, we cann't wait all Day — the
Actions are a Thouſand Pound———— you ſhall have time
to ſend for Bail, and what Friends you Pleaſe.
 Mr Sago. A Thouſand Pound? [*Enter Mrs. Sago.*] Oh!
Lambkin have you Spent me a Thouſand Pound.
 Mrs. Sago. Who, I Pudd? Oh! undone for Ever——
 Mr. Sago. Pud me no Pud,——do you Owe Mr. *Tabby* the
Mercer Two Hundred Pounds? Ha.
 Mr. Sago. I, I, I, don't know the Sum Dear Pudd— but,
but, but I do Owe him ſomething; but I believe he made
me Pay too Dear.
 Mrs. Sago. Oh! thou Wolfkin inſtead of Lambkin——
for thou haſt Devour'd my Subſtance; and doſt thou Owe
Mr. *Dollor* the *Goldſmith* Three Hundred Pound? Doſt
thou? Ha, ſpeak Tygreſs.
 Mrs. Sago. Sure it cann't be quite Three Hundred
Pound. [*Sobbing.*]
 Mr. Sago. Thou *Iſland* Crocodile thou —— and doſt thou
Owe *Ratsbane* the *Vintner* a Hundred Pound? And
were thoſe Hampers of Wine which I receiv'd ſo Joyfully
ſent by thy ſelf, to thy ſelf? Ha.
 Mrs. Sago. Yes indeed, Puddy ———— I, I, I, beg your
Pardon. [*Sobbing.*]
 Mr. Sago. And why didſt not thou tell me of them? Thou
Rattle-ſnake ?—— for they ſay they have ſent a Hundred
times for their Money———— elſe I had not been Arreſted
in my Shop. I 2 Mrs.

Mrs. Sago. Be, be, be, becauſe I, I, I was afraid, Dear Puddy. [*Crying.*]

Mr. Sago. But wer't not thou afraid to Ruin me tho, Dear Pudd. Ah! I need ask the, no more Queſtions, thou Serpent in Petticoats; did I Doat upon thee for this? Here's a Bill from *Calico* the *Linnen-Draper*, another from *Setwell* the *Jeweller* ——— from *Coupler* a *Mantua-Maker*, and *Pimpwell* the *Milliner*; a Tribe of Locuſts enough to undo a Lord Mayor.

Mrs. Sago. I hope not, truly, Dear, Dearey, I'm ſure that's all.

Mr. Sago. All with a Pox———no Mrs. *Jezebel*, that's not all; there's Two Hundred Pound Due to my ſelf for Tea, Coffee and Chocolet, which my Journey-man has Confeſs'd ſince your Roguery came out ——that you have Imbezell'd, Huſwife, you have; ſo, this comes of your keeping Quality Company ——— e'en let them keep you now, for I have done with you, you ſhall come no more within my Doors I promiſe you.

Mrs. Sago. Oh! Kill me rather; I never did it with Deſign to part with you, indeed Puddy. [*Sobbing.*]

Mrs. Sago. No, no, I believe not whilſt I was Worth a Groat. Oh!

Enter Sir James.

Sir James. How! Mrs. *Sago* in Tears, and my honeſt Friend in Ruffins Hands; the meaning of this.

Mrs. Sago. Oh! Sir *James* ——my Hypocritical Wife is as much a Wife as any Wife in the City ——I'm Arreſted here in an Action of a Thouſand Pound, that ſhe has taken up Goods for, and Gam'd away; get out of my fight, get out of my fight, I ſay.

Mrs. Sago. Indeed and indeed. [*Sobbing.*] Dear Puddy but I cannot — no, here will I Hang for ever on this Neck.
 [*Flies about his Neck.*]

Mrs. Sago. Help, Murder, Murder, why, why, what will you Collar me?

Sir James. Right Woman, I muſt try to make up this Breach — Oh! Mr. *Sago*, you are unkind ——— 'tis pure Love that thus Tranſports your Wife, and not ſuch Baſe Deſigns as you Complain of. Mrs.

Mrs. *Sago.* Yes, yes, and ſhe run me in Debt out of pure Love to no doubt.

Mrs. *Sago.* So it was Pudd.

Mr. *Sago.* VVhat was it ? (Ha Miſtreſs) out of love to me that you have undone me ? Thou, thou, thou, I don't know what to call thee bad enough.

Mrs. *Sago.* You won't hear your Keckey out, Dear Pudd, it was out of Love for Play,— but for Lo, Lo, Love to you, Dear Pudd ; if you'll forgive me I'll ne'er play again.
(Crying and Sobbing all the while.)

Sir *James.* Nay, now, Sir, you muſt forgive her.

Mrs. *Sago.* What, forgive her that would ſend me to Jayl ?

Sir *James.* No, no, there's no Danger of that, I'll Bail you, Mr. *Sago,* and try to Compound thoſe Debts.—— You know me Officers.

Officers. Very well, Sir *James,* your Worſhip's Word is ſufficient.

Sir *James.* There's your Fees, then leave here your Priſoner, I'll ſee him forth coming.

Officers. With all our Hearts ; your Servant, Sir. [*Exit.*]

Mr. *Sago.* Ah thou wicked Woman, how I have doated on thoſe Eyes ! How often have I kneel'd to kiſs that Hand ! Ha, is not this true, Keckey?

Mrs. *Sago.* Yes, Deary, I, I, I, I do confeſs it.

Mr. *Sago.* Did ever I refuſe to grant whatever thou ask'd me ?

Mrs. *Sago.* No, never, Pudd.—— [*Weeps ſtill.*]

Mr. *Sago,* Might'ſt thou not have eaten Gold, as the Saying is ? Ha ?—— Oh Keccky, Keecky ! [*Ready to weep.*]

Sir *James.* Leave Crying, and wheedle him, Madam, wheedle him.

Mrs. *Sago.* I do confeſs it, and cann't you forgive your Keckey then that you have been ſo Tender of, that you ſo often confeſt your Heart has jump'd up to your Moturh when you have heard my Beauty prais'd.

Mr. *Sago.* So it has I profeſs, Sir *James,*—— I begin to melt,———— I do ; I am a good-natur'd Fool, that's the Truth on't : But if I ſhould forgive you, what would you

do to make me Amends? For that Fair Face, if I turn you out of Doors, will quickly be a cheaper Drug than any in my Shop.

Sir James. And not maintain her half ſo well; —— pro-miſe largely, Madam. [*To Mrs.* Sago.]

Mrs. Sago. I'll Love you for ever, Deary.

Mr Sago. But you'll Jigg to *Covent-Garden* again.

Mrs. Sago. No, indeed I won't come within the Air on't, but take up with City Acquaintance, rail at the Court, and go Twice a Week with Mrs *Outſide* to *Pin-makers-hall.*

Mr. Sago. That would rejoice my Heart. [*Ready to weep*]

Sir James. See, if the good Man is not ready to weep; your laſt Promiſe has conquer'd. —— Come, come, Buſs and be Friends, and end the Matter.— I'm glad the Quarrel is made up, or I had had her upon my Hands. (*Aſide.*)

Mrs. Sago. Pudd, don't you hear Sir *James,* Pudd?

Mr. Sago. I can hold no longer,— yes, I do hear him,—— come then to the Arms of thy n'own Pudd.

 (*Runs into one another's Arms*)

Sir Jam. Now all's well; and for your Comfort Lady *Reveller* is by this Time married to my Lord *Worthy,* and there will be no more Gaming I aſſure you in that Houſe.

Mr. Sago. Joys upon Joys. Now if theſe Debts were but Accommodated, I ſhould be happier than ever; I ſhould indeed Kickky.

Sir Jam. Leave that to me, Mr. *Sago,* I have won Part of your Wife's Money, and will that Way reſtore it you.

Mr. Sago. I thank you, good Sir *James,* I believe you are the Firſt Gameſter that ever Refunded.

Mrs. Sago. Generouſly done,--- Fortune has brought me off this Time, and I'll never truſt her more.

Sir James. But ſee the Bride and Bridegroom.

Enter Lord Worthy *and Lady* Reveller, *Lady* Lucy, Buckle, Alpiew.

Lady Lucy. This Match which I have now been Witneſs to, is what I long have wiſh'd, your Courſe of Life muſt of Neceſſity be chang'd.

 Lady

Lady *Revel.* Ha, Sir *James* here !—— Oh if you love me, my Lord let us avoid that Brute, you muſt not meet him.

S r *James.* Oh, there's no Danger, Madam.-- My Lord, I wiſh you Joy with all my Heart; we only quarrell'd to make you Friends, Madam, ha, ha, ha.

Lady *Revel.* What, am I trick'd into a Marriage then?

Lord. Not againſt your Will, I hope.

Lady *Revel.* No, I forgive you ; tho' had I been aware of it, it ſhould have coſt you a little more Pains.

Lord. I wiſh I could return thy Plot, and make this Lady thine, Sir *James.*

Sir *James.* Then I ſhould be paid with Intereſt, my Lord.

Lady *Lucy.* My Fault is Conſideration you know, I muſt think a little longer on't.

Sir *James.* And my whole Study ſhall be to improve thoſe Thoughts to my own Advantage.

Mr. *Sago.* I wiſh your Ladiſhip Joy, and hope I ſhall keep my Kickey to my ſelf now.

Lady. With all my Heart Mr. *Sago,* ſhe has had ill Luck of late, which I am ſorry for.

Mrs. *Sago.* My Lord *Worthy* will confine your Ladiſhip from Play as well as I, and my Injunction will be more caſie when I have your Example.

Buckle. Nay 'tis Time to throw up the Cards when the Games out.

Enter Sir Richard, *Captain* Hearty, Lovely *and* Valeria.

Capt. Well, Sir *James,* the Danger's over, we have doubled the Cape, and my Kinſman is Sailing directly to the Port.

Sir *James.* A Boon Voyage.

Sir *Rich.* 'Tis done, and my Heart is at Eaſe.— Did you ever ſee ſuch a perverſe Baggage, look in his Face I ſay, and thank your Stars, for their beſt influences gave you this Husband.

Lovely. Will not *Valeria* look upon me ? She us'd to be more kind when we have fiſh'd for Eals in Vinegar.

Val. My *Lovely,* is it thee ? And has natural Sympathy for born to inform my Senſe thus long ? [*Flies to him.*

Sir *Rich.* How ! how ! This *Lovely ?* What does it p——
the Enſign I have ſo carefully avoided ! L.

Lovely. Yes, Sir, the ſame ; I hope you may be brought to like a Land Soldier as well as a Seaman.

Sir Rich. And, Captain, have you done this?

Capt. Yes, Faith, ſhe was too whimſical for our Element; her hard Words might have Conjur'd up a Storm for ought I know——— ſo I have ſet her aſhore.

Lady Revel. What, my Uncle deceiv'd with his Stock of Wiſdom ? Ha, ha, ha.

Buckle. Here's ſuch a Coupling, Mrs. *Alpiew,* han't you a Month's Mind ?

Mrs. Alp. Not to you I aſſure you.

Buckle. I was but in Jeſt, Child, ſay nay when you're aſk'd.

Sir James. The principal Part of this Plot was mine, Sir *Richard.*

Sir Rich. Wou'd 'twas in my Power to hang you for't. [*Aſide.*

Sir James. And I have no Reaſon to doubt you ſhould repent it, he is a Gentleman, tho' a younger Brother, he loves your Daughter, and ſhe him, which has the beſt Face of Happineſs in a married State ; you like a Man of Honour, and he has as much as any one, that I aſſure you, Sir *Richard.*

Sir Rich. Well, ſince what's paſt is paſt Recal I had as good be ſatisfied as not, therefore take her, and bleſs ye together.

Lord. So now each Man's Wiſh is Crown'd, but mine with double Joy.

Capt. Well ſaid, Sir *Richard,* let's have a Bowl of Punch, and Drink to the Bridegroom's good Voyage to Night,——ſteady, ſteady, ha, ha.

Mr. Sago. I'll take a Glaſs with you Captain,——— I reckon my ſelf a Bridegroom too.

Buckle. I doubt Kickey won't find him ſuch. [*Aſide.*]

Mrs. Sago. Well,—— poor Keckky's bound to good Behaviour, or ſhe had loſt quite her Puddy's Favour.

Shall I for this repine at Fortune ?—— No.
I'm glad at Heart that I'm forgiven ſo.
Some Neighbours Wives have but too lately ſhown,
When Spouſe had left 'em all their Friends were flown.
Then all you Wives that wou'd avoid my Fate.
Remain contented with your preſent State

F I N I S.

CPSIA information can be obtained
at www.ICGtesting.com
Printed in the USA
LVOW09s0025050917

547552LV00018B/882/P